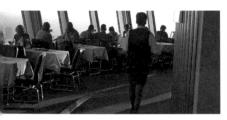 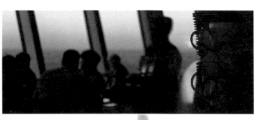 

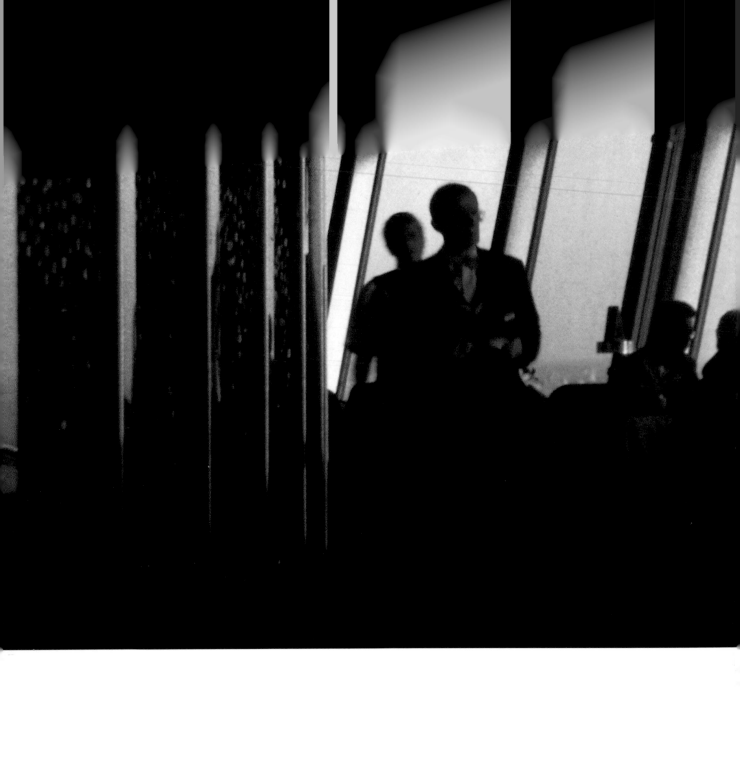

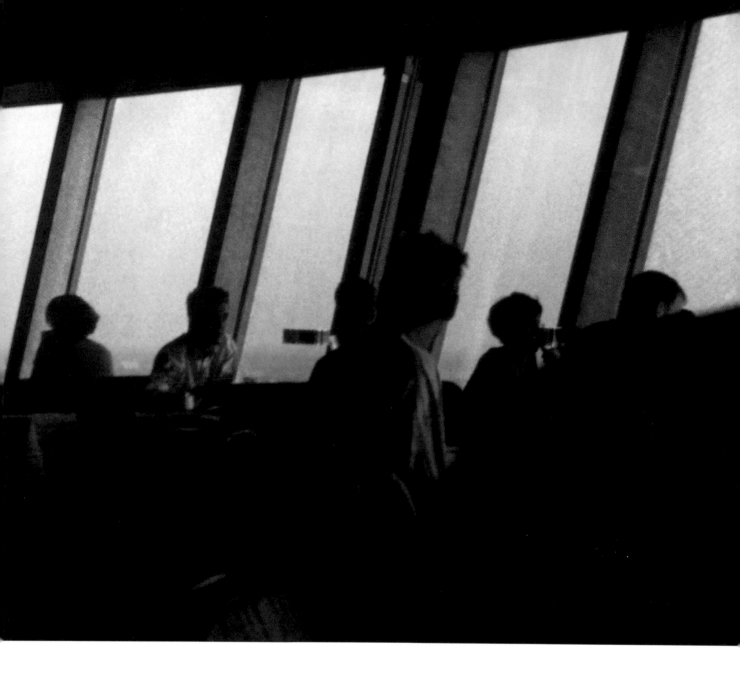

Tacita Dean

Cover and frontispiece:
Location photographs from *Fernsehturm* 2001

Published by order of Tate Trustees 2001
on the occasion of the exhibition

## Tacita Dean
Recent films and other works

at Tate Britain, London
15 February–6 May 2001

ISBN 1 85437 355 2

A catalogue record for this publication is
available from the British Library

Published by Tate Gallery Publishing Limited,
Millbank, London SW1P 4RG

All photographs of works by the artist kindly supplied by
Frith Street Gallery, London

Catalogue design by Philip Lewis
Printed and bound in Great Britain by
Balding + Mansell, Norwich

# Contents

# Foreword

Tacita Dean's emergence in the 1990s as a young artist of great, and growing, stature has been recognised in widening circles in Europe and America in the recent past. This exhibition, the first at Tate Britain to survey the recent work of a contemporary artist in some depth, may prove to be another stage in this process of revelation. In 1996 a Tate *Art Now* commission, *Foley Artist*, was followed by her solo exhibitions in Rotterdam, Philadelphia, Dundee, Tilburg and elsewhere, as well as regular shows at the Frith Street Gallery, London and the Marian Goodman Gallery, New York. In 1998 she was shortlisted for the Turner Prize and, in summer 2000, at the Museum für Gegenwartskunst in Basel, Switzerland, Theodora Vischer staged a memorable selection of Dean's works from 1996 to 2000 which helped to inspire our decision to mount a substantial exhibition here at Millbank.

Dean's steady filtration into the consciousness of those who make or curate or write about art professionally has been insistent, but her work has always reached out readily to touch eyes and minds beyond these confines. Often, indeed, the narratives that underpin her essays in film, sound, text and other media are themselves shaped by encounters with figures from diverse contexts and places who cross the artist's path during the genesis of a work. They join and mingle with us, the audience, in Dean's gently unfolding journeys of exploration across the territories of natural, created and mental landscape, and through the shifting relationships between the immutability of history, the longings of now, and the expectations of tomorrow. We move across oceans and timezones, from Kentish turf to Yemeni souk, from Cornish cliff to Berlin tower, from Teignmouth to Cayman Brac – locations, never destinations. For Dean's visual and intellectual narratives are not resolved by endings:

they require and request their audience's participation and speculation and are thereby offered with an apparently generous ambiguity. But they can never stray far from their rooting in the monumental, the universal – in time itself, in cycles and in rhythms, natural and man-made – and they insist with a quiet morality that they carry meanings for us all.

Many of the several writers in this book have found themselves, at one time or other, taking part in some way in such narrations. Dean has engaged each of them through her art and her presence, and she has inspired the compelling diversity of their contributions here. I am extremely grateful to them all – to J.G. Ballard, Simon Crowhurst, Germaine Greer, Michael Newman, Friedrich Meschede, Peter Nichols, Sean Rainbird, Susan Stewart and Clarrie Wallis – for agreeing to write for us. It was hardly a difficult task to persuade them. I would also like to note particular thanks to the several Tate staff through whom the exhibition took shape: the guiding contributions of Nicholas Serota, Sheena Wagstaff and Sean Rainbird, and, especially, the curatorship of Clarrie Wallis, whose combination of flair and determination was both consistent and inspired. Others who helped decisively in various ways include Tim Batchelor, Mathew Hale, Jane Hamlyn, Philip Lewis, Rose Lord, Sue MacDiarmid, Katherine Rose and the book's editor, Mary Richards. We are also pleased to acknowledge the generosity of those who have lent to the exhibition, especially The British Council and the Emanuel Hoffman Foundation. Above all, meanwhile, we would like to thank Tacita Dean.

Stephen Deuchar
DIRECTOR
Tate Britain

*Eddystone Lighthouse in a Storm*
Vignette on the title page of Smeaton's *Narrative
of the building of Eddystone*, from a drawing by
one of his daughters.

Reproduced in *English Lighthouse Tours 1801, 1813,
1818 from the diaries of Robert Stevenson with his
drawings of Lighthouses*, ed. D. Alan Stevenson,
London 1946.

# Introduction

CLARRIE WALLIS

'How many maps, in the descriptive or geographical sense, might be needed to deal exhaustively with a given space, to code and decode all its meanings and contents?'
HENRI LEFEBVRE

'It is evident that we are hurrying onwards to some exciting knowledge – some never-to-be-imparted secret, whose attainment is destruction.'
EDGAR ALLAN POE

Tacita Dean is an artist concerned with the concept of navigation – both literally and metaphorically. Her work addresses the process of plotting co-ordinates in space and time, making connections between past and present, fact and fiction. Dean maps not just the objective world but also our private worlds and traces the complex interaction of the two. The depiction of different locations is matched by *dis-locations* in space and time: real landscapes circumscribed by the horizon are intimately imbricated with inner, psychic landscapes defined by our own desires and obsessions. The *relic,* as dislocation from an original signifying context which is now lost, is central to Dean's work: we are shown objects and places that are charged with a meaning that we cannot fully read, often depicting a failed or abandoned vision.[1]

From her earliest works Dean has used film, photography, drawing and sound in a lyrical, often narrative way to explore notions of time, serendipity and the relationship between different interpretations of history. Dean's more recent works have ranged from a pilgrimage of sorts to Rozel Point, the site of Robert Smithson's now submerged *Spiral Jetty* 1970, to charting the course of the sun during a solar eclipse. She has also realised a number of works based on an aural record of a twenty-four hour period from 12.00 noon Friday to 12.00 noon Saturday, in eight points around the world, each separated by 45 degrees longitude. Dean's *Jukebox 1* 2000 functions like a time machine, giving visitors the opportunity to select ambient sound recordings from diverse locations, and to be conceptually transported to another place and time.

Throughout her career, Dean has been fascinated by the sea, its meanings and associations. The sea as interpreted in films such as *Disappearance at Sea* 1996, offers us visions, darknesses and revelations. Its genealogy can be traced back to eighteenth-century notions of the sublime, where elemental forces were viewed as emblems of turbulent and ungovernable human emotions.[2] In Edgar Allan Poe's *MS. found in a Bottle* and *Narrative of Arthur Gordon Pym,* for example, sailing upon the seas mirrors an inner journey. The ship's voyage of discovery is at the same time an inner revelation for the narrator, combining enlightenment and terror in equal measure.

Dean's concern ranges from a practical interest in the physics of waves and turbulence – as demonstrated by the short black and white film of a Dutch wave machine, *Delft Hydraulics* 1996 and *The Sea Inventory Drawings* 1998, one of a series of blackboard drawings – to an investigation into what it is that draws people to put themselves afloat on the deep, dark, indifferent waters. These works reflect the artist's appreciation of the physical beauty of water under the influence of wind and tide. In particular, *Delft Hydraulics* highlights how the wave is born out of the delicate intercourse between the elements. Dean is also attracted to tales of amateur sailing, which was itself a product of the Romantic revolution; in an over-civilised Europe, the sea was understood to be the last true wilderness.[3] She is similarly preoccupied with the disappearance of Donald Crowhurst during the Golden Globe Race of 1968, and the conceptual artist Bas Jan Ader's fateful attempt to cross the Atlantic Ocean, as part two of his project *In Search of the Miraculous* 1975.[4] Both embraced the physical and psychic aspects of their respective journeys but were lost at sea.

The quest for a reliable method of navigation was one of the most perplexing problems of marine history. Unable to establish their longitude accurately, it was not uncommon for ships to find themselves far off course on the vast oceans. When this problem was finally solved by the English clockmaker John Harrison, a group of eminent scientists met in Washington

and took a ruler to the globe, allocating longitudes diverging east and west from Greenwich. Space and time were seen to be conquered. Yet attempts at map-making, to translate an image of the world into a flat two-dimensional representation, belies our day to day understanding and experience of things: personal and physical geographies have proved much harder to pin down.[5]

In the autumn of 1968, Donald Crowhurst set out from Devon in his untested trimaran, a competitor in the first single-handed non-stop around-the-world race. Eight months later, the boat was found abandoned, 1,800 miles from the coast of England. In the course of attempting to solve the mystery of Crowhurst's disappearance, his logbooks were recovered from the boat, *Teignmouth Electron*. Subsequent analysis revealed that, although Crowhurst had radioed messages from his supposed round-the-world course, he had in fact never left the Atlantic Ocean.

For Crowhurst, who was seeking a new direction in life, this voyage represented more than simply a thirst for adventure, played out against an epic backdrop of nature at its most wild. Rather, in the tradition of the classic sea stories, his journey was to have been a rite of passage: the end of the old self and the birth of the new – an escape, in this instance from business worries, with the chance of a triumphant homecoming and a new beginning.

Tragically, the reality of the situation he found himself in proved to be somewhat different. Having set sail in an ill-prepared vessel, Crowhurst quickly ran into difficulties. Unable to face the prospect of withdrawing from the race he embarked on faking his navigational record. Calculating backwards from an imagined distance to a series of daily positions he hypothesised plausible conditions for a record-breaking journey ('Saturday, 7th December. 1400 Going very well. Wind

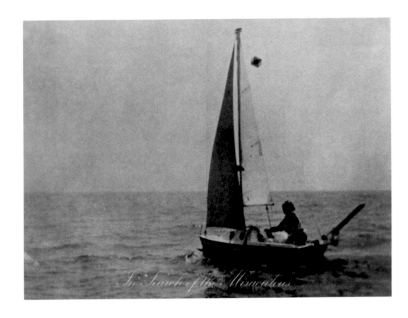

ENE 6 gusting over 25 kt') and so deluded the world about his progress.[6] Trapped by a fatal combination of bravado and deceit, he retreated into a private world. Floating between time zones, obsessed with time-keeping and the belief that he was journeying through prehistory, Crowhurst's final diary entries are a manifesto or testament of sorts, in which he attempted to express a revelation that had dawned on him. His conviction that man had evolved to a state where the mind could prevail without the body, provided him with the rationale to jump overboard, abandoning the race in pursuit of a higher existence. It is significant that Crowhurst went over the side with the ship's chronometer, abandoning the common measure of clock time for the private time (or timelessness) of his own revelation.

*Disappearance at Sea* is the first in a series of works inspired by the Crowhurst story. It is also one of four films in which the motif of the lighthouse or beacon appears. Throughout history these buildings have fulfilled a complex role. As landmarks they have enabled mariners to establish precise locations offshore, to calculate distance, speed and course. They have also fulfilled a symbolic purpose as a form of guidance representing the first and last outpost of civilisation and a point of reference for human contact. The lonely vigil of the keeper's watch was traditionally seen as proof that no one at sea was ever completely alone.

The film charts nightfall as seen refracted in the Fresnel lenses of the St Abb's Head Lighthouse in Berwickshire, cutting between a shot looking inwards at the bulbs orbiting each other and a view out to sea; it ends with the descent into darkness, evoking a sense of loss. The constancy of the light beam sweeping across the darkened coastline contrasts with the vast expanse of black sea, an aid for those who have lost their bearings.

As a counterpoint, *Disappearance at Sea II (Voyage de Guérison)* 1997 was shot in daylight in the Longstone Lighthouse in the Farne Islands, Northumberland. Filmed in one continuous take, the camera was positioned on the lighthouse's revolving apparatus, offering a panoramic view of the deserted blue sea beyond. The sound track is punctuated by the soft rhythms of

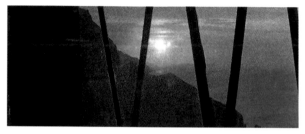
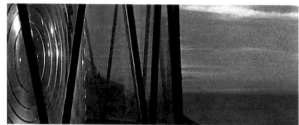
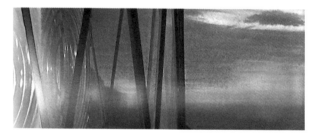

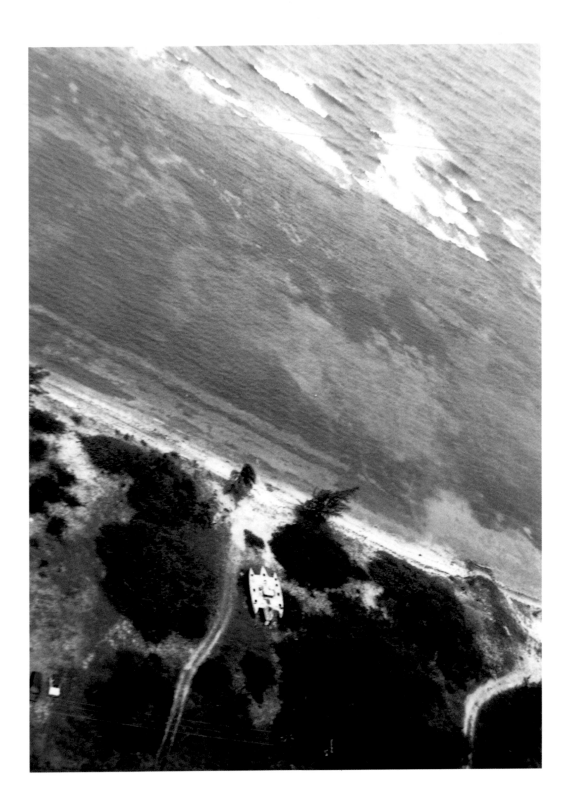

*Teignmouth Electron* 1999
Black and white photograph, 100 × 66 cm

short wave radio signals. This mesmerising short film was inspired by an extract from the twelfth-century romance *Tristan and Isolde*. Tristan, mortally wounded in a duel, is told that the only hope of a cure rests with the Queen of Ireland. After completing most of the journey in a ship, he is set adrift in a small boat with only his harp for company ('His fate he left to heaven's care, however he himself might fare').[7] And so Tristan, like Crowhurst, surrenders himself to Providence and the sea. However, unlike Crowhurst, Tristan's voyage is a journey of healing, of rescue and redemption. The film concludes with almost blinding sunlight shining directly into the camera lens and the melancholic refrain of someone (perhaps Crowhurst) attempting to establish radio contact is lost forever.

For Dean, the Crowhurst tragedy is a cautionary tale that has entered modern mythology. The artist has commented, 'His is a story about human failing; about pitching his sanity against the sea',[8] and elsewhere, 'The Sixties was a time of exploration, of moon travel and experimentation . . . I do not believe anyone could have predicted what might happen if things went wrong: the flip side of success.'[9] She views the cultural climate and the combination of small town endeavour coupled with the glamour of national publicity as partly to blame for Crowhurst's fate.

On 20 July 1969, ten days after the *Teignmouth Electron* was found abandoned, *Apollo 11* touched down on a very different sea, the *Sea of Tranquility*. While the collective imagination was captured by the grainy black and white images of Neil Armstrong and Buzz Aldrin walking on the moon, the fate of moon exploration in the intervening thirty years is as telling an emblem as any of how the world was about to change.[10] It was a singular moment in the twentieth century, when a few individuals, as pioneers, adventurers, even myth makers, were seen collectively to carry the world's hopes and aspirations. In retrospect this period can be viewed as a golden age of post-war optimism, where the impossible seemed to be within grasp, and was seen as such almost immediately it came to an end at the beginning of the 1970s and a feeling of disillusionment set in.

The sense of abandoned or failed vision that underlines Dean's interest in the Crowhurst story, resurfaces in other works, her films *Bubble House* 1999 and *Teignmouth Electron* 2000: the trimaran now permanently beached among the tropical vegetation of Cayman Brac is kept company by an equally desolate half-complete Bubble House, a 1970s prototype, designed to withstand hurricane conditions. As the artist has commented, the house is the boat's 'perfect companion . . . a failed futuristic vision'.[11]

Her films are haunted by architectural relics which seem to embody outmoded or bankrupt beliefs, but at their time of execution promised much. In hindsight, even Dean's light-houses provide us with a reminder of a time when there was the belief that science and technology could conquer all.

Once part of England's coastal defence system, the Hythe Sound Mirrors were built in the 1920s and 1930s, at a time when the prospect of air attack presented a new danger to national security.[12] These listening devices acted as an acoustic warning system, aiding early detection of enemy aircraft. In their heyday large 'concrete ears' projected out towards the English Channel; sounds from the atmosphere were collected by the discs and focused. They were then relayed to an operator, who was seated below in a concrete enclosure. The success of early experiments with radar meant that by 1936 the RAF lost interest in the mirrors and they became obsolete, like the redundant neighbouring Martello Towers constructed in the nineteenth century to stop a much feared Napoleonic invasion. 'When they were built . . . nothing stood between them and the sea; and between them and France. Now the ground where they stand has been flooded and turned into a gravel pit. The mirrors have begun to erode and subside into the mud: their demise now inevitable.'[13]

Shot in black and white, *Sound Mirrors* 1999 appears anachronistic and unreal, as if the nominal realities of time and space have ceased to exist. The film's heightened sense of sound, reinforces awareness of the discs' role as amplifiers. What little signs of human presence there are seem intent on departing: the sound of a distant steam train; a small plane

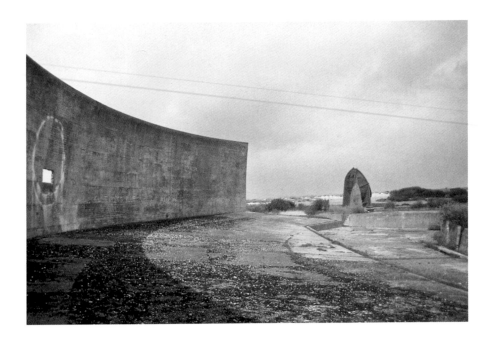

taking off from Lydd airport, its wings silhouetted against the April sky; the roar of a motorbike. While the structures are reminiscent of ancient monoliths, they also call to mind abandoned futuristic antennas for some kind of surveillance or interplanetary communications system. Almost surrounded by water, the mirrors appear to be drowning in an entropic landscape that is slowly returning to its prehistoric past.

Dean's most recent work was filmed on location in the Berliner Fernsehturm. A product of the Cold War, this television tower was built in the late 1960s. Dominating the cityscape, a watchtower and a tower to be watched, its presence re-inforced the crusading element of the confrontation between international powers. Today it remains a popular haunt for Berliners from the former Eastern block and the curious tourist. Visitors to the revolving Telecafé restaurant are offered a 360 degree vision of the capital, a new perspective of the reunited city, and a space defined on a human scale.

Edited to 44 minutes *Fernsehturm 2001* captures the transition from day to night. While it has properties in common with both the *Disappearance at Sea* films, its spatial qualites are more complex. On one level it acknowledges the cyclical nature of restaurant life; the opening and ending frames show the restaurant almost deserted with a waitress tending to the table settings. Yet somehow the film is as much about the external as internal space and, as is often the case with Dean's work, light. As the sun sets, the film is bathed in a golden glow. Shadowy, ethereal figures, oblivious to the camera's lens, talk amongst themselves and point down at the city below. Further into the film the Berlin landscape appears as a vast dark sea, extending into the distance.

In similar fashion to *Disappearance at Sea II*, Dean explores the way the human sensorium is restricted and makes clear that from any vantage point our perspective is constrained by the surrounding horizon. The spherical shape of the restaurant reinforces the sense of it being a self-contained world with its own particular planetary motion and half of which, like the Earth, is perpetually shrouded in darkness. This spherical space represents at once both a personal world and the terrestrial

globe, and as such Dean reminds us that the world is a whole of which we can only percieve the parts. Thus Dean's science of navigation plots the co-ordinates of places that stand at the threshold between worlds, the liminal states between the inner and the outer, mute yet haunting relics not found in any standard chart or atlas.

## Notes

1. Dean's interest in the relic can be traced back to an early film, *The Martyrdom of St Agatha* 1994, which tells the story of the breasts of the third-century Sicilian saint, and what became of them.
2. See Jonathan Raban (ed.), *The Oxford Book of the Sea*, Oxford 1992.
3. Ibid.
4. Ader set sail from Cape Cod, Massachusetts to Falmouth, England on 9 July, 1975. Radio contact was lost after three weeks. Remains of his boat were discovered seven months later off the coast of Ireland. See *Bas Jan Ader*, exh. cat., Mary Porter Sesnon Art Gallery, Santa Cruz 1999.
5. See *Map*, Institute of International Visual Arts, exh. cat., London 1996.
6. Nicholas Tomalin and Ron Hall, *The Strange Last Voyage of Donald Crowhurst*, Adlards Coles Nautical, London 1995, p.136.
7. *The Tristan and Isolde of Gottfried Von Strassburg*, tr. Edwin H. Zeydel, Cincinnati 1948, p.70.
8. *Tacita Dean: Location*, exh. cat., Museum für Gegenwartskunst, Basel 2000, p.25.
9. Ibid., p.26.
10. Hopes that the space programme would lead to exploration and exploitation of the lunar surface proved to be still born; *Apollo 17*, 1972 was the last manned flight to the moon.
11. *Tacita Dean: Location*, p.36.
12. For a detailed account of the history of the Hythe Sound Mirrors, see Richard N. Scarthe, *Echoes in the Sky*, Hythe Civic Society 1999.
13. *Tacita Dean: Location*, p.40.

ABOVE *Disappearance at Sea II* (*Voyage de Guérison*) 1997
16mm film still

OVERLEAF Location photograph of Longstone lighthouse, Farne Islands, Northumberland, for *Disappearance at Sea II* (*Voyage de Guérison*) 1997

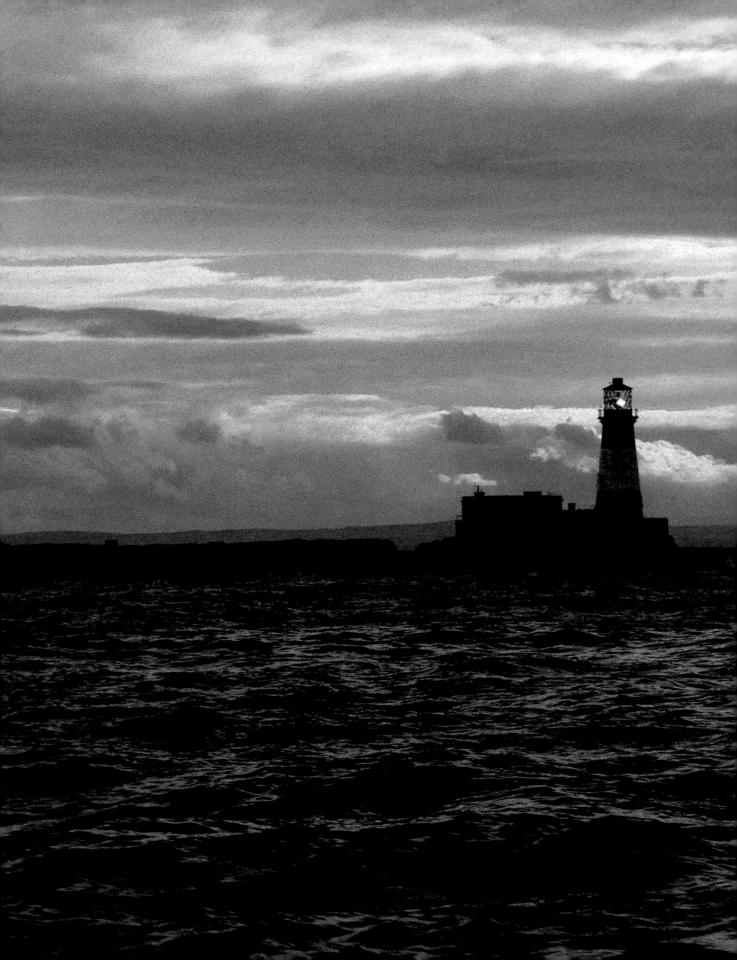

# A seat over the wings

SEAN RAINBIRD

An usherette leaves a theatre. Passing along a back corridor she goes through the stage door into an alleyway. She enters a pub, exits again. Then there are sounds of crunching shingle on a windy beach. Returning to the theatre, through sound-muffling doors, she enters the auditorium as the closing lines of a play are being spoken. Separately recorded tracks combined on a length of magnetic tape create aural thresholds. Beyond them are small increments of time reverberating to the sounds of each episode. We are the still centre as they move round our senses. *Foley Artist's* aural journey, its blind orbit around the beginning and end of a play, is a drama hidden from our eyes. In the final scene of Ionesco's *Les Chaises* the lighthouse keeper jumps from the window and the curtain drops in front of a stage littered with empty furniture. Then come noises of scraping chairs, shuffling feet and coughing: unseen events on stage live on in the imagination of the audience.

Is the visual a stronger trigger of memory, or is it the recollection of other sensations? Attune to the changing atmosphere as the artist ascends to film *A Bag of Air* 1995. Listen to its whisper as you watch the balloon's eclipsing shadow glide over the ground. Only we cannot properly hear it, for aural precision is lost in the transfer from magnetic tape to the optical track on film. Owing to the distortions of technology, this is an advantage to the visual. Watch the shadow of the helicopter lightly touching the dirt track curling in on itself in Robert Smithson's film of his *Spiral Jetty* 1970. Swinging low over water ruffled by the downdraft, its rotors loudly scythe the air. Perhaps a loud machine is needed to redress the balance back towards the aural. The roar of hot-air burners in *A Bag of Air* drowns out other subtler atmospheres.

In *Disappearance at Sea* 1996 seven shots progress from near to far, the camera positioned for long takes. Its lens sets focal depth and breadth of field, creating a visual path through the vista ahead, framing its sides and giving the boxed view its

*Totality* 2000, 16mm film still

extremes of proximity and distance. In slow stages dusk reddens into night. Sounds change from the grinding of a revolving lighthouse lantern to the general din of screeching gulls above breaking waves. At the end a circling beam of light sweeps across the shore at intervals, leaving equally regular measures of pitch blackness. Those sounds in the darkness intensify an unquantifiable anxiety beyond the shore. *Disappearance at Sea II* 1997 also conveys blindness. The camera's rotating motion comes to a standstill where sunlight is reflected on water. A journey's end, that final shot lasts long enough to dilate the irises of anyone watching: one blinks from a physical sensation of retinal burn. Like Turner's paintings of Venice, colour relationships within the image, not the sun's actual strength, give it a piercing intensity, a force of dissolution.

There are other moments of power too: the sea Dean imagines enfolding Donald Crowhurst as he steps from his boat into the ocean; a shower she films as it moves across the sea towards the Bubble House, a stumbled-upon relic of unfulfilled dreams. The approaching rain muffles the waves and bleaches the sky to soft whiteness. Then, with a sudden violence, raindrops spatter the camera lens, breaching the membrane between the view and our viewing. Equally unexpected and riveting is the appearance of a cat padding along the farmyard wall in *Banewl* 1999, momentarily quickening the slow rhythm of morning milking. Then there is the banking climb of an aeroplane, lifting off from Cayman Brac's beachside aerodrome in *Teignmouth Electron* 2000. Curving slowly upwards the camera fixes upon the hulk of Crowhurst's boat, beached above the tideline as it diminishes to an unrecognisable speck. Recall another vision of disappearance, Smithson's belief in the sunken, salt-encrusted Spiral Jetty, sucked into its own vortex to drain into the distant ocean.

All Dean's works are conditioned by weather. Sunset, wind, storm, clouds and rain give them their natural drama in large format or tiny detail. *Banewl* captures the full eclipse phenomenon of light fading, sharply dipping then gradually returning to the atmosphere, using the instincts of birds and cattle as emotional barometers. *Totality* 2000 presents the same event, but at its most minimal and without sound. As much as the scene before the lens, it reflects perhaps the predicament of an artist exposed to the vagaries of weather in so planned a medium as film-making. *Totality* uses footage of the minutes before, during and after the darkest phase of the eclipse when the moon completely covers the sun. Dean films with a camera tracking the movement of the cloud-obscured sun. It is a monochrome study as subtly nuanced as Robert Ryman's white surfaces, and as bereft of optimism as Gerhard Richter's swirly grey Inpaintings of the 1970s. But the film astonishes as do Richter's paintings. A rare alignment experienced as the least event, it is an act of willpower against negation, an uncovering of endless variety in the most restricted conditions. The silvery glow of daylight fades to a grainy texture just visible on the surface of the screen, the barest indication that a film is running. Just as endurance of this non-image becomes unbearable, fleeting clouds in the lightening sky give a hint of known shapes. Released from the pressure of spatial blankness and temporal absence, time renews its passing.

Gerhard Richter, 326/3 *Untitled, Grey* 1972, oil on canvas, 250 × 250 cm
Hessisches Landesmuseum Darmstadt

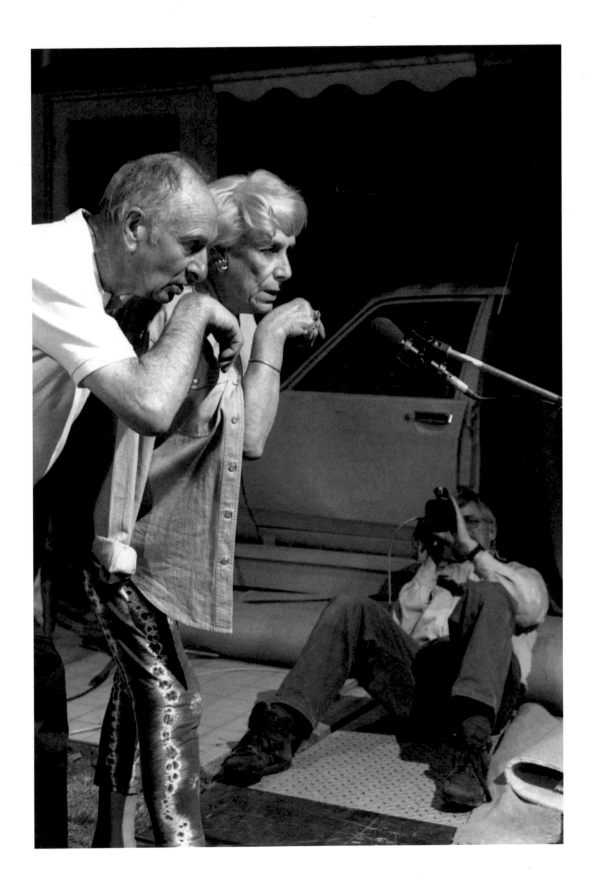

*Foley Artist* 1996, location photographs

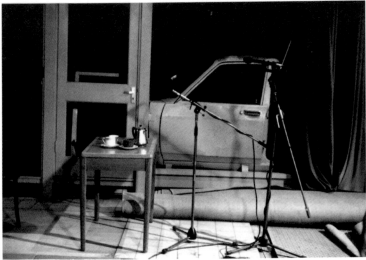

*Foley Artist* 1996, location photographs

# Medium and event in the work of Tacita Dean

MICHAEL NEWMAN

The mediums of art are concretions of time. Such concretion takes a different form in each medium and in each work. Paintings and sculptures delay, condense and spread out time in their own way. So do photographs, films and videos. Each medium and each work posits a distinct relation between past, present and future. The photograph re-presents the past as present in the trace of its absence. Film presents a record of the past's passing which is recreated in the present. Video acts as a real-time flowing correlate of the past as present. Technological changes, such as the speed of film, the kinds of lenses available, the rate at which video is able to scan the data, also affect the temporality of the medium.

Media are recording, reproducing and broadcasting technologies. The 'mediums' of art, as Rosalind Krauss has argued,[1] are not simply physical vehicles for an image or expression, rather a medium is what has in cinema studies been called an 'apparatus' for example, a system including camera, projector, screen, and the relation of each to the other and to the spectator.[2] Mediums are not identical to media, but they are not separate either, since the possibility and meaning of a medium as used in art shifts with historical changes in media technology: the advent of television as a mass-medium, followed by video taking over the role of home movies, have transformed the possibilities of film, particularly in 8 and 16 millimetre formats, allowing it to convey a sense of fragility and loss in the experience of its subliminal flicker. Analog media are no less artificial than digital ones: the difference is that in the former the artifice is manually constructed, for example by editing strips of celluloid, transferring from one magnetic tape to another, literally cutting up strips of time, and physically adding sound, rather than being programmed. From the mid- to late 1960s artists increasingly explore film as a physical medium, both in its inherent plasticity, and as sensation in relation to the perceptual apparatus of the viewer.

A development in media can free a pre-existing medium for another kind of use, although more than that is currently at stake. If, as Walter Benjamin has suggested, the redemptive possibility of a technological form is glimpsed at the moment of its obsolescence ('redemption [*Rettung*]', here as much in the sense of 'salvage' as in its theological resonance),[3] it is by no means impossible for a medium to undergo more than one moment of obsolescence. If film became available to art in the 1960s because it was in the process of being displaced from mass-cultural dominance by television, the situation today is not the same. The issue is no longer how to distinguish mediums from each other or different uses of a medium within a given state of technological development (as in the relation between cinema and artists' films in the 1960s), but rather of *whether a medium as such is even possible* in the context of the technological transformation – specifically the digitalisation of media as a whole. This situation has been described by Friedrich Kittler:

> The general digitalization of channels and information erases the differences among individual media. Sound and image, voice and text are reduced to surface effects, known to consumers as interface. [...] Inside the computers themselves, everything becomes a number: quantity without image, sound, or voice. And once optical fibre networks turn formerly distinct data flows into a standardized series of digitalized numbers, any medium can be translated into any other. With numbers, everything goes. Modulation, transformation, synchronization; delay, storage, transposition; scrambling, scanning, mapping – a total media link on a digital base will erase the very concept of medium.[4]

When all data-flows are digitalised and accessed through a single interface, sound, vision and text become fluid and interchangeable. This is clearly the case at the level of production, but it also affects reception. On the one hand, digital technologies create the possibility of a new kind of montage, involving 'sampling', the transfer of the same material across different outputs, and new uses by the consumer, including a degree of control over the time of reception and the repeatability of what is recorded. On the other hand, what is lost is the physical sense of the transcription of an irreversible, finite temporality into a medium that is itself finite and subject to degradation and loss

(the loss of loss). Indeed, against the unification and totalisation of media through the digital, the finitude of mediums stands out all the more strongly. This finitude is connected with the distinctness of the bodily relation to the different mediums, not only at the level of perception, but also sensation and physiology, and not simply in terms of a fetishised materiality, but as a component of the apparatus where the medium involves a relation. Kittler points out a distinction between the gramophone, which 'registers acoustic events as such',[5] reproducing the single audio data stream, and film, which works by cutting up the data stream, minimally into 24 frames per second, thereby creating physiologically an illusion of a continuous reality, an 'imaginary' to the 'real' of the gramo-phone.[6] Which is not, of course, to exclude the intersection of these media, as in audio-editing and the tape cut-up technique.

The assimilation of mediums into digitalised media is the situation that Tacita Dean confronts in her works of art using sound, film, photography and video, as well as in her blackboard drawings. In each case in her work, there is an articulation of time, space and the body that is specific to the medium being used. However, there is also a common feature that hints at the general condition that is being addressed, and that establishes a relation with the earlier moment in which media were displaced from mass-cultural use to become mediums for art.

This common feature is the disappearance or erasure of the horizon,[7] which I would argue is literally or metaphorically at play in all her work. The horizon is that limit in relation to which we are situated, and against which things appear to us as the things that they are, at a certain distance. It has a literal sense in the experience of perception, and a metaphorical sense in our practices of interpretation, connecting the two. A transforma-tion of the horizon changes everything, the loss of horizon means utter disorientation, the destruction of the world. However, this 'destruction' can open up the possibility of a relation with another, infinite time and space. By making a connection between the emblematic figures who mean a lot to Tacita Dean – the sailor Donald Crowhurst, the artists Bas Jan Ader and Robert Smithson, and the writer J. G. Ballard[8] – it is possible to see that they are linked by a sense of a profound alteration in, or loss of, the horizon of the world. Crowhurst loses his sense of location at sea and eventually drowns himself; Bas Jan Ader is lost at sea while making a work, In Search of the Miraculous 1975, which involves sailing to the horizon; Smithson makes works and writes texts which see the world from the perspective of geological rather than historical time; and Ballard in the 1960s writes novels and stories in which a change in a process – a forest starts turning into crystal, or rivers and lakes dry up – linked to a modification in the way time works, transforms the basis of the experience of the world.

What has become more evident since the 1960s and 70s is the connection of the loss of horizon to the mutation of media, and the change in the sense of a 'medium' that this has brought about.

Tacita Dean's displacements of mediums frequently explore a relation between obsolescence, decay and dereliction, and a memory of a future that was once imagined but remains unrealised, or the detritus of which has been left behind. This is achieved in a mode of presentation that for each work is quite precise in relation to bodily and situated experience, for example, through the determination of the size and surface of the screen and the relation to the wall of the projection as they affect the physiological response of the viewer. What is salvaged in art, *contra* the 'interface' of interchangeable media in the global simultaneity of 'real time', is the possibility of a particular medium that emerges in the moment of its obsolescence, and the difference of mediums with respect to each other. We find in Dean's work at least five interconnected concerns. First, a reflection of the medium in the subject matter: the wave machine in *Delft Hydraulics* 1996 becomes an analogy for film; a Cinemascope-shaped window looks onto the coming storm in *Bubble House* 1999, the parallel of lighthouse and projector in *Disappearance at Sea* 1996; the listening-structures in *Sound Mirrors* 1999 focus attention on the role of sound in the film. Second, works that highlight the

disappearance of the perceptual horizon: the darkness that falls to be penetrated by the beam of light in *Disappearance at Sea*; the darkening of the horizon in both *Banewl* 1999 and *Sound Mirrors*, in both cases triggering a lighthouse; the coming of the storm that effaces the horizon in *Bubble House*. Third, a connection between a journey or search, and either an uncertain destination, or the loss or leaving of something behind: the search for a work of land art that may not be there any more in the sound piece *Trying to Find the Spiral Jetty* 1997, or the past location of which is uncertain in the video *From Columbus, Ohio to the Partially Buried Woodshed* 1999; the discovery of and aerial departure from Donald Crowhurst's boat in *Teignmouth Electron* 2000. Fourth, the use of artifice to construct or reconstruct an effect: this is celebrated in *Foley Artist* 1996, and practised in both *Trying to Find the Spiral Jetty* and *Disappearance at Sea*. And fifth, narrative, which enters into the work in the following ways: as a story, such as that of Donald Crowhurst, to which the latter work refers; as a narrative that is constructed by the work, in *Trying to Find the Spiral Jetty* and *Foley Artist* (in both cases through sound); and as the movement of an event, often with the progress to and from a climax, involving either a mechanically induced process, such as the rise and decline of the perfect wave in *Delft Hydraulics*, weather, as in the coming of the storm in *Bubble House*, or time, as in the day in the life of a listening structure in *Sound*

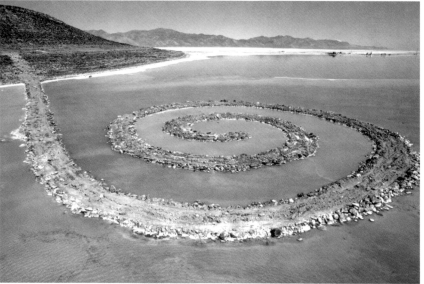

FAR LEFT  *From Columbus, Ohio to the Partially Buried Woodshed* 1999, video stills

LEFT  *From Columbus, Ohio to the Partially Buried Woodshed*, location photograph

ABOVE  *From Columbus, Ohio to the Partially Buried Woodshed*, video still

RIGHT  Robert Smithson, *Spiral Jetty* 1970

*Mirrors*, or the progression from light to darkness and back in the films of the eclipse *Banewl* and *Totality*. In an epoch of virtually instantaneous global communication, we are reminded of processes and forces which we can never control, and of a time that is more than human time. In *Jukebox 1* 2000, recalling the controls of a 1960s fantasy time-travelling spaceship, we are reminded, in the other direction, of the irreducible specificity of what occurs, in a narrative of sounds recorded from Friday to Saturday, at each particular moment, there and then.

Making the connection between these various aspects of Tacita Dean's work, we can begin to discern that what is at stake is the very possibility of an event, of something happening, and of its presentation. By linking the narrative of an event with the historicity of the medium, the promise of which emerges precisely in its marginality and obsolescence, the here and now as the only possible locus for such a precise physiological experience is opened up to the untimeliness that inhabits it.[9]

## Notes

1.  For Rosalind Krauss's discussions of medium, including the relation of inventing a medium to obsolescence, see in particular ' ". . . And Then Turn Away?" An Essay on James Coleman,' *October* 81, Summer 1997; 'Reinventing the Medium', *Critical Inquiry* 25, Winter 1999; and *'A Voyage on the North Sea': Art in the Age of the Post-Medium Condition*, London 1999.

2.  See Teresa de Lauretis and Stephen Heath (eds.), *The Cinematic Apparatus* London 1980.

3.  For the effect of obsolescence on a medium, see Walter Benjamin, 'Little History of Photography' in *Selected Writings Volume 2 1927–1934*, Cambridge, Mass. and London 1999, pp.507–530; for his redemptive version of historical materialism, see 'Theses on the Philosophy of History,' *Illuminations*, London 1973, pp.255–266. See also Susan Buck-Morss, *The Dialectics of Seeing: Walter Benjamin and the Arcades Project*, Cambridge, Mass. and London 1989.

4.  Friedrich Kittler, *Gramophone, Film, Typewriter,* Stanford 1999, pp.1–2.

5.  Ibid. p.23.

6.  Ibid. p.115–18.

7.  See my catalogue essay 'Horizonlessness', in *Terra Incognita*, curated by Lynne Cooke at the Neues Museum Weserburg, Bremen, (Heidelberg: Edition Braus,1998), pp.41–51.

8.  The connection between Smithson and Ballard is made in an essay by Jeremy Millar, 'Messieurs les inventeurs d'épaves,' in *Tacita Dean*, exh. cat., Institute of Contemporary Art, University of Pennsylvania, Philadelphia 1998–99, pp.30–42.

9.  These reflections grew out of the experience of guest-curating an exhibition of works by Tacita Dean at the Art Gallery of York University, Toronto (18 Oct–19 Nov, 2000), which included *Trying to Find the Spiral Jetty,* 1997 (audio CD), *Teignmouth Electron*, 1999 (photograph), *Sound Mirrors*, *Bubble House* and *Delft Hydraulics*, with *From Columbus, Ohio to the Partially Buried Woodshed* as part of an accompanying screening program. The relation of these works to obsolescence, film and Land art are briefly discussed in a brochure accompanying the exhibition, remarks that will be extended in a forthcoming catalogue (AGYU, Toronto and Yves Gevaert, Brussels 2001).

FOLLOWING PAGES
*Rozel Point, Great Salt Lake, Utah* 1997, 35mm slide projection;
Fax instructions from Utah Arts Council for finding Robert Smithson's *Spiral Jetty*

SPIRAL JETTY

Detailed directions:

1.  Go to the Golden Spike National Historic Site (GSNHS), 30 miles west of Brigham City, Utah.  The Spiral Jetty is 15.5 dirt-road miles southwest of the GSNHS.

To get there (from Salt Lake City) take I-80 north approximately 65 miles to the Corinne exit, just west of Brigham City, Utah.  Exit and proceed 2.5 miles west, on State Highway 83, to Corinne.  Proceed through Corinne, and drive another 17.7 miles west, still on highway 83, to Lampo Junction.  Turn west off highway 83 at Lampo, and drive 7.7 miles up the east side of Promontory Pass to the GSNHS.

2.  From the Visitor Center at the GSNHS, drive 5.6 miles west on the main dirt road running west from the Center.  Remember to take the county dirt road...not the railroad grade.

3.  Five point six miles will bring you to an intersection. From this vantage you can see the lake.  And looking southwest, you can see the low foot hills that make up Rozel Point, 9.9 miles distant.

4.  At this intersection the road forks:  One road continues west and the other goes south.  Take the south fork.  Both forks are Box Elder County Class D (maintained) roads.

5.  Immediately you cross a cattle guard.  Call this cattle guard #1.  Including this one, you will cross four cattle guards before you reach Rozel Point and the Spiral Jetty.

6.  Drive 1.3 miles south.  Here you will see a corral on the west side of the road.  Here too, the road again forks.  One fork continues south along the Promontory Mountains.  This road leads to a locked gate.  The other fork goes southwest toward the bottom of the valley and Rozel Point.  Turn onto the southwest fork, just north of the corral.  This is also a Box Elder County Class D road.

7.  After you turn southwest, you will go 1.7 miles to cattle guard #2.  Here, besides the cattle guard, you will find a fence but no gate.

8.  Continue southeast 1.2 miles to cattle guard #3, a fence, a gate, and a sign on the gate which reads, "Promontory Ranch."

9.  Another .50 miles will bring you to a fence but no cattle guard and no gate.

10.  Continue 2.3 miles south/southwest to a combination

fence, cattle guard #4, iron-pipe gate...and a sign declaring the property behind the fence to be that of the Rafter S Ranch. Here too, is a "No Trespassing" sign.

11.  If you choose to continue south for another 2.3 miles, and around the east side of Rozel Point,  you will see the Lake and a jetty (not the Spiral Jetty) left by oil drilling exploration in the 1950's. As you approach the Lake, you will see an abandoned, pink and white trailer (mostly white), an old army amphibious landing craft, an old Dodge truck...and other assorted trash.

The trailer is the key to finding the road to the Spiral Jetty.  As you drive slowly past the trailer, turn immediately to the west, passing on the south side of the Dodge, and onto a two-track trail that contours above the oil-drilling debris below.  This is not much of a road!  In fact, at first glance it might not look to be a road at all.  Go slow!  The road is narrow;  brush might scratch your vehicle, and the rocks, if not properly negotiated, could high center your vehicle.

12.  Drive .6 miles west/northwest around Rozel Point and look toward the Lake.  The Spiral Jetty should be in sight.

Maps of the area:
      BLM 1:100,000 Surface Management maps - Available at the BLM's State Office Public Room, 324 South State Street, Salt Lake City, Utah  84111  phone: (801) 539-4001
            (1)  Tremonton
            (2)  Promontory

      U.S. Geological Survey, 7.5 minute series - Available at the U.S.G.S., Federal Building, 125 South State Street, Salt Lake City, Utah 84111  phone: (801) 524-5652
            (1)  Golden Spike Monument Quadrangle
            (2)  Rozel Quadrangle
            (3)  Rozel Point Quadrangle

For Additional Information:

      Bureau Of Land Management
      Salt Lake District
      2370 South 2300 West
      Salt Lake City, Utah 84119
      phone: (801) 977-4300

      Golden Spike National Historic Site
      P. O. Box 897
      Brigham City, Utah  84302
      phone: (801) 471-2209

*Bubble House* 1999, colour photograph, 111 × 140 cm

# Time and Tacita Dean

J.G. BALLARD

Tacita Dean's films are surveillance footage taken in some of the strangest spaces of the mind. At first sight the settings seem to be located in the real world – steam baths in Hungary, an abandoned trimaran on a Caribbean island, a futuristic beach-house still waiting for its real owners to arrive. The spectator's imagination flows into these cryptic and eventless spaces, trying to decode and make sense of them. I assume that Tacita's films are deliberate attempts to explore a mysterious agenda of her own. A hint of what this might be first came to me when she wrote from Utah describing her attempts to find Robert Smithson's *Spiral Jetty* 1970, a pioneering work of Earth art that had disappeared below the surface of an immense saline lake. She included a set of instructions on how to find the jetty, published by the Utah Arts Council. The directions are so complex that they seem designed to mislead anyone searching for the jetty. Tacita believes that the instructions were provided by Smithson himself. One could guess that Smithson, who was soon to die in a plane crash, was posthumously protecting his unique memorial.

In an article about the jetty, I tried to answer the question: what conceivable cargo could be landed at this bizarre, self-enclosed wharf? I concluded that the cargo was probably a time-machine, though not the kind found in science fiction, but a device for manipulating time and space, and that all Smithson's Earthworks were similar 'metaphors' working in parallel.

It intrigued me that Tacita was so interested in Smithson. I was struck by the thought that all Tacita's films are obsessed with time. The clearest example of this is her interest in Donald Crowhurst, who disappeared at sea in 1969 while ostensibly taking part in a non-stop race around the world. As was soon known, Crowhurst never left the Atlantic, radioing in false reports of his positions. Eventually he despaired and jumped overboard, and the trimaran later found itself on Cayman Brac, a Caribbean island where Tacita filmed its rotting hulk.

Tacita writes well – perhaps too well for an artist – and has described Crowhurst's tragic story in vivid and gripping prose. She refers to the rumours of collusion between Crowhurst and certain unnamed people in Teignmouth, his home port. Her history of the abandoned trimaran's subsequent career is a tour de force of melancholy reporting, brought out most tellingly in her film. Nearby is the strange beach-house, standing like a piece of the future that has arrived too early.

But what most interests Tacita is the fate of Crowhurst's marine chronometer, which he seems to have taken with him when he jumped to his death. Tacita suggests that Crowhurst had run out of time, and that the chronometer was no longer telling any kind of time that made sense to him. After circling the Atlantic for months, he was psychologically and spiritually exhausted. The timeless void of an ocean death was all that was left to him.

There's no doubt that, for Tacita, the trimaran also lies outside time, like so many of the subjects that she has filmed. She told me recently that the saline lake in Utah has fallen by several feet, revealing the labyrinth of the spiral jetty. I'm confident that Tacita will be on hand with her camera when the cargo is at last unloaded.

*Bubble House* 1999, location photograph

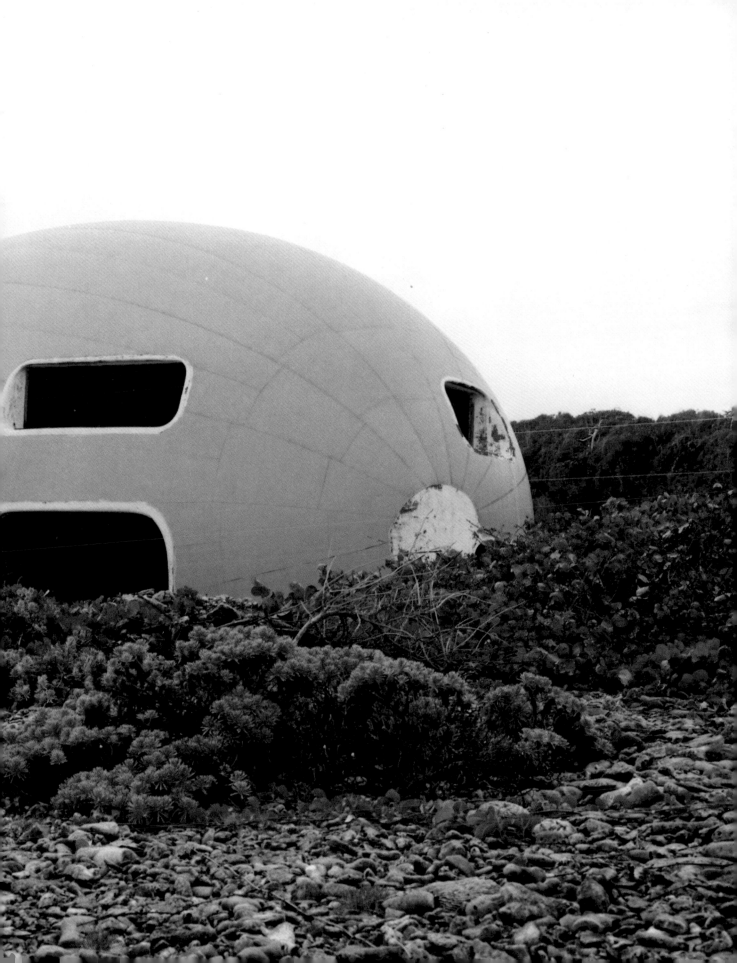

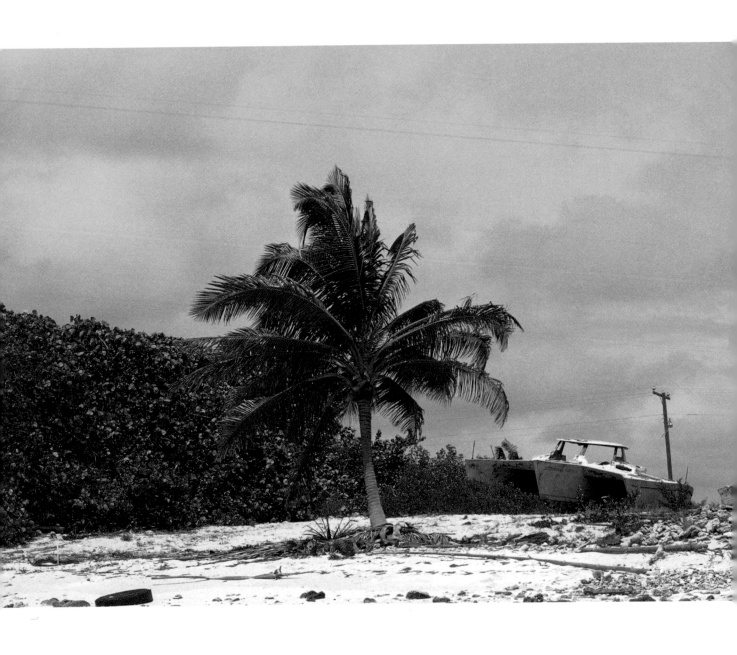

*Teignmouth Electron* 2000, location photographs

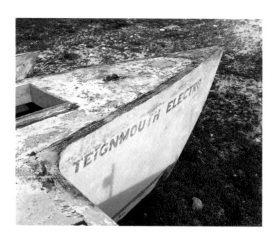

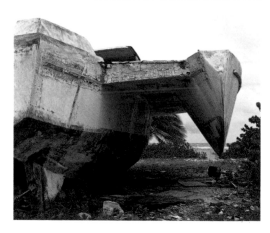

*Teignmouth Electron* 2000, location photographs

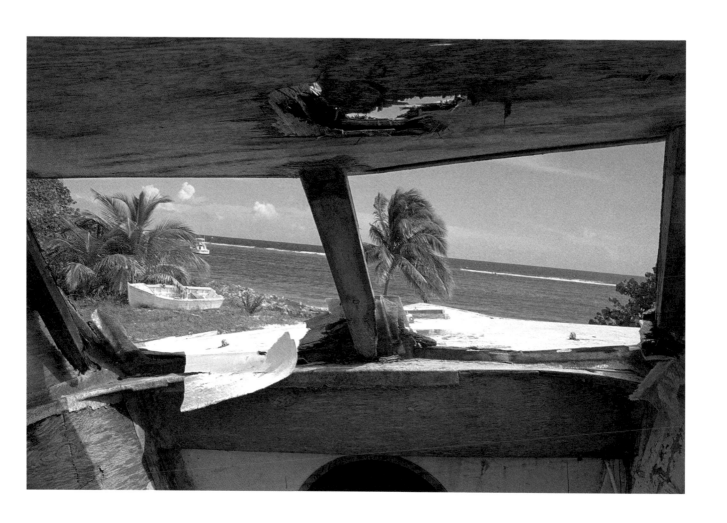

# Tacita Dean

## GERMAINE GREER

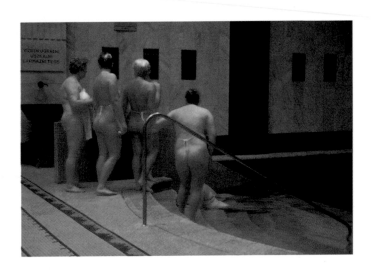

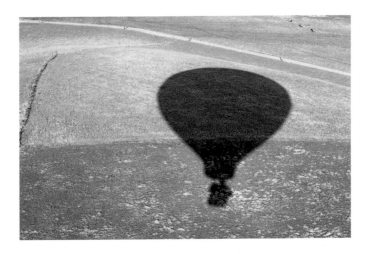

ABOVE *Gellért* 1998, Lambda print, 38 × 59 cm

BELOW *A Bag of Air* 1995, 16mm film still

I think Tacita Dean may be a great artist. For many years it was, and for all I know may be still, heresy to contest the statement that women could not be great artists because they were excluded from the life class, even though there were great women painters of the figure, from Artemisia to Mary Cassatt, and what we didn't have amongst women artists was a great landscape painter. We had thousands of takers and makers of views, thousands of sketch-books, but no landscape artists. The landscape was peppered with ladies sketching away, to no result, not even an Edward Lear, let alone a Turner. Now we have Tacita Dean.

Eventually I came to the opinion that it was the picture-frame that was the problem for women painters; women would not or could not snap off a chunk of visual experience, disconnect it from the continuum, and sign their name to it as more real than real, the 'work'. I reckoned that women's making, women's *poesis*, was open-ended. It was a strand in the unsynthesised manifold and not a defiance of it. Women's creativity worked in children's haircuts, in making and mending things that wore out, in leaving blinds half-down or half-up, turning lights off or on, modifying rather than controlling the actual – I think.

So much art is about art, but there is, there must be an art which is about life, an art which has hardly been able to call attention to itself, an art without monuments. A self-conscious female artist can hardly avoid the attempt to mediate between monumental art and her own way of seeing; historically this has meant that too often she became her own subject and therefore the victim of a law of steadily diminishing returns. Conceptual art offers a way out from under the mantle of greatness to a freer realm where ways of seeing can be informed and transformed, where the artist's vision is in vision, and the artist can place herself, as it were, nowhere. *Gellért* 1998 which Dean shot herself, is remarkable in that there is no sense of a gaze dominating the naked female figures, which remain utterly contained, moving calmly through a field of vision unheated by lust or disgust, in an implicit and character-istically understated comment on every heap of frolicking

'baigneuses' ever assembled on canvas. Great God'amighty, free at last!

Photography was the medium that could free women's creativity, because photography could not be disconnected from the event that it witnessed, the genes of the figures that it observed, its datedness. The story that the camera eye tells may be distorted but hardly invented. The blinds may be up or down, the lights on or off. In *A Bag of Air* 1995, the balloon is high in the sky, the bag is a real bag, the air real air and the mystery no puzzle to decipher, but the actual mystery of the sky.

Tacita Dean's art can be thought of as following the ancient narrative of journeying, like a picaresque novel without a hero. It is not a Bildungsroman in which the protagonist's character is delineated and developed, because the subject is not the seer but the seen. The presentation is deceptively artless, though one is often conscious of arbitrary discontinuities, like eye-blinks or the interruptednesses of memory. All the juxtapositions are, of course, deliberate, but they are made to free the images from interpretation, which means that they may not be emptied out and dismissed. The images remain whole like the perceptions of a child who has not learnt to name what she sees. In much of her work Dean uses this stranger's eye perspective, as if refusing to organise or dominate her material, and in this I find something truly female, distinct from the self-assertion of proto-feminist artists predicated as it is on the self-promotion of the masculinist tradition.

Dean follows and weaves a skein of threads through actuality, accepting the given, clear air instead of clouds, for example, and insisting at all points on contacts with the circumstantial that intrude rather than being orchestrated; her style is a flight from style, backing away from ego rather than

building a monument to it. Occasionally she comments upon this dynamic herself, as in *How to put a Boat in a Bottle* 1995. The ship in the bottle is a witty reduction of the self-defining, self-limiting work of art, which the woman struggles to replicate. The subject of the art is not the object but the struggle for the object, art as process, the rhythm of the hands and fingers expressed in the looping patterns of the strings, surrounding the man's story of himself, and the ultimate, almost violent, penetration of the bottle. At every point there is the insistence on distance, on a degree of ironic alienation from the intense activity, suspended in a medium of gentle coolness. The ship and the bottle remain embedded in the actual, the serendipitous cry of the seagulls and the nasal whine of the passing moped, the Dimple Haig-ness of the bottle. The camera could creep up to the bottle and enter its world of suggested tempest, but it remains aloof. Adventure fantasy remains contained, collapsed upon itself.

That fantasy world was entered in *The Roaring Forties: Seven Boards in Seven Days* 1997. In white chalk on blackboards eight feet square, Dean drew shots from a non-existent action movie ('The [yet to be made] Storm' maybe), with an exaggerated chiaroscuro, as if recording an overlit scene in the manner of Piazzetta. The ephemerality of the chosen medium made its own comment on the would-be monumentality of the action, and of the directorial instructions that implied that the heaving scenes with their tipping perspectives were all staged. The nervous drawing however was full of a fire and energy that were quite unphotographic, that had much more to do with actual risk and actual loss, and with high art as we used to understand it. Once again Dean had shifted her viewpoint, both paying homage to the adventurer tradition, and subtly under-lining her own exteriority to it, as a stowaway on the ship of art.

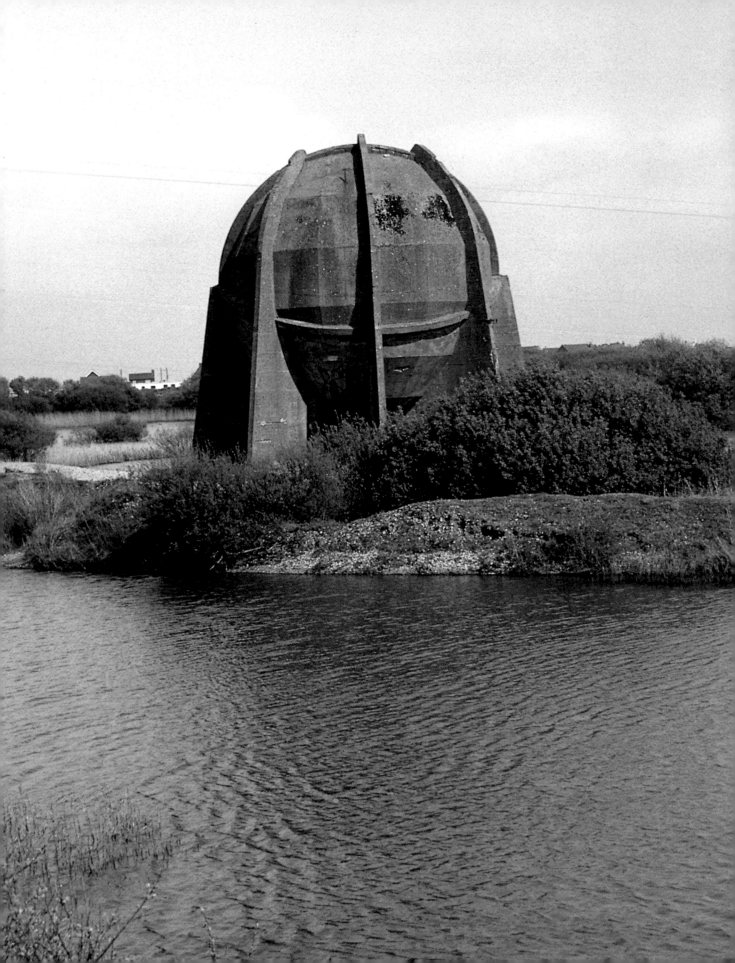

*Sound Mirrors* 1999, location photographs (and overleaf)

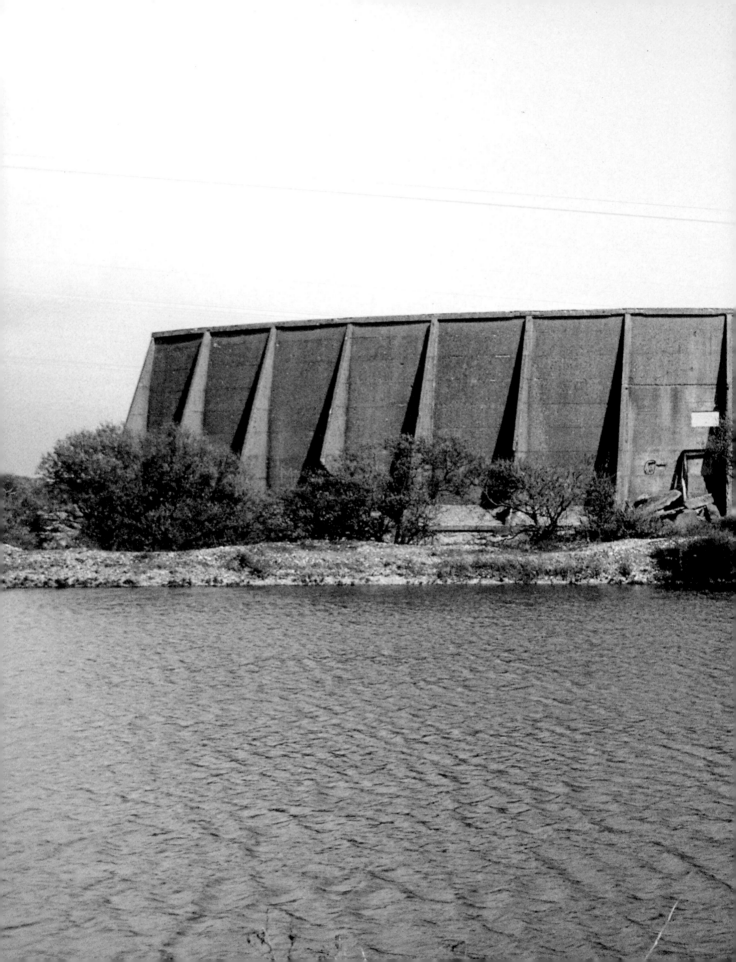

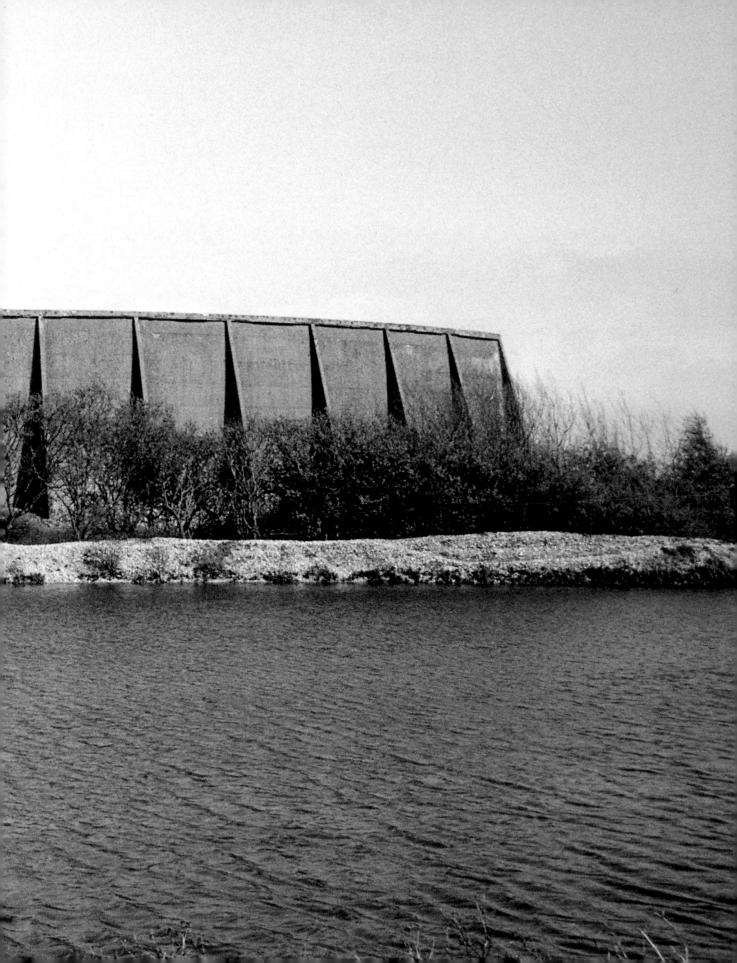

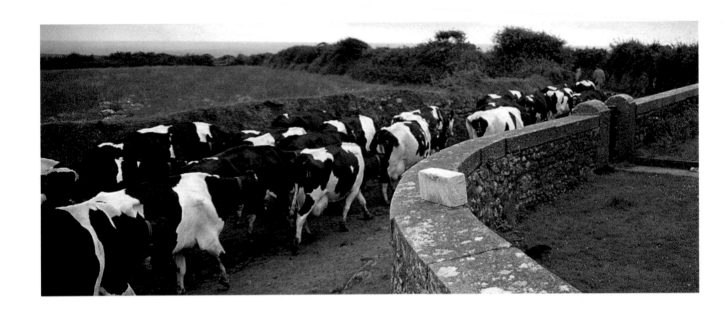

*Banewl* 1999, 16mm film still

# The light of *Banewl*

SUSAN STEWART

O dark, dark, dark, amid the blaze of noon,
Irrecoverably dark, total eclipse
Without all hope of day!
O first-created beam, and thou great Word,
'Let there be light, and light was over all';
Why am I thus bereaved thy prime decree?
The sun to me is dark
And silent as the moon,
When she deserts the night,
Hid in her vacant interlunar cave.
Since light so necessary is to life,
And almost life itself, if it be true
That light is in the soul,
She all in every part, why was the sight
To such a tender ball as th'eye confined?

MILTON, *Samson Agonistes*

On 11 August 1999 at 11.11 am a total eclipse of the sun was
visible above the Cornwall coast. Tacita Dean's *Banewl* records
63 minutes of that event at the site of Burnewhall Farm, a dairy
farm by the sea; the film's title is a phonetic transcription of
the local pronunciation of the farm name. *Banewl* is deeply
embedded in concepts of time and universality: it is heavily
'dated' and lightly 'signed'; the artist's consciousness is evident
in the work's conception and in the process of attending and
then turning away that puts the human gaze and human
behaviour more generally within the cycle of nature. The film
explores the vast space implied by these famous lines of
Milton's blind poet soliloquising on his blindness in the context
of another eclipse: the all-encompassing greatness of the sun's
light and the smaller world of our tender-eyed perception.

If someone wanted to narrate *Banewl,* the account would
be something like this:

There is the vastness of the sky and then a tree makes a land-
scape. The barnyard flowers blow in the wind, the stone house
stands, and a herd of Holsteins waits behind a broad steel gate,
all facing toward the path that will take them to their grazing
meadow by the sea. The herd is led by a man in red overalls. It is
followed by a man wearing a cotton shirt. The hooves of the
cows make a clopping sound on the earth. The cows bellow
deeply; their stride is loping and calm. They switch their tails at
the insects worrying their flanks. A bird chirps. The sea crashes
in the distance. The barnyard stands empty.

Approaching the open meadow, the cows hesitate and then
move off into their individual patterns of grazing. One cow
mounts another. A dog bites and gnarls at her fleas, then gazes
out to sea. Clouds move swiftly across the sky. The wind makes
a great singing hum and airplanes now and then can be heard
off-screen. A crow, or perhaps a jackdaw, suddenly flies by, a
black blur across the foreground. Then all is still, a deep grey
cloud cover against a nacreous sky, and the cows can be heard
chomping on the grass. A clutch of swallows, woodpigeons and
crows roosts on telephone wires. The sky darkens. The cows
move toward each other and begin to lie down to graze.
Swallows assemble and send up an agitated racket. The cows
prick their ears and a breeze stirs the grasses. As the cows
become more still, they flick their ears and tails against the
onslaught of insects.

Then the darkness descends and the cows lie down on
their sides. A lighthouse beam becomes gradually visible at
mid-horizon and then the horizon disappears, leaving only
the beam.

And then the light begins its slow return. A twitching ear
flicks on the horizon, then the whole animal becomes gradually
visible. The birds begin to sing as if it were dawn. The wind picks
up. The chomping begins again. A cock crows. A cat comes
exploring. Gulls circle in the sky. Like a blurred star above deep
black clouds, then more diffusely, like light seen through a
screen of milk, the sun gradually, partially, begins to emerge.
The moon is moving away even though it cannot be seen.
Billowing light clouds move swiftly across the sky. The blue-grey
sea swells below, then a dark swath of clouds like smoke courses
the sky and returns: opaque, then transparent, then broken
through by light.

A brood of woodpigeons grazes insects from a corrugated
tin roof. A cockerel pecks from behind a wire cage. Other birds,

invisible, sing behind the trees. A long branch is filled with sparkling leaves that rustle in the wind like the play of light on water. A cow releases a steaming cowpad beneath her raised and stiffened tail. A plane can be heard far away. The dark clouds pass before the sun breaks through again. A hawk flies past. A cow walks off into the distance. The clouds continue; the sun, the complete round radiance of the sun, has returned. The screen turns blank and black and the credits appear.

What 'happens' in *Banewl* the film is the articulation of memory – the memory of the action of photographers and crews of assistants working four cameras with anamorphic lenses during the 2 hours and 40 minutes of the eclipse. The footage is later shaped by Dean's complex artisanal process of editing that carefully preserves the exact temporal sequence of the filming. At the close of the film, the sun is in place in ordinary time and space and, as we leave the screening room, we, too, return to the world of everyday existence where we are objects of the sun living under the sun. The cows, who most often graze in crepuscular light, at dawn or dusk, are first stimulated by the change in light and then quieted by it. The swallows go wild and other birds recede from the scene, often roosting for the night – that time when they must avoid predators. The film can be considered as an intended and original work of art by its maker and at the same time as one of the responses of our own species to the extraordinary event of the eclipse.

Our hearing delights in the subtle buzzes, chomps, clomps, and clops of the animal world, in the differences between the distanced sounds of the sea and the wind, in the mechanical hum of the planes and perhaps motor boats in the even farther distance. Our sense of touch delights in the film's variegated surfaces: the stone crest of the wall in the foreground, the bony backs of the receding cows; the tough silken whorls of the blazons on the cows' foreheads; the fragile fur of the cat and the waving petals of the summer flowers; the gnarled bark and smooth steel gate. Our sense of colour delights in the flinty earth, red with iron, and the red overalls of the cowherd, the many gradations of grey and smoke in the passing clouds, the stark black-on-white and white-on-black cloud-like patterns of the Holsteins' pelts, the overwhelming green of the meadow. The film does not mark its artifice, but within its artifice are the direct associations of lived experiences in the world.

All life depends on the sun and this is a masterpiece made of light and sounds sustained and diminished by the light of the sun. Our entire sense of the cycle of nature depends on the sun as the epicentre of our world. Yet an eclipse of the sun is an opening to the idea of a gap or break in the universe, an idea that it is almost impossible to bear. When we hear the rustling of the leaves in the tree, it is each individual leaf that is rustling, but we hear only the sound of the whole. In the modes of patient attention followed in *Banewl*, each flower, each leaf, each individual animal and bird and insect, is suggested as a particular and universal at once. We see the heifers reacting subtly to the camera; we see the empty space of the barnyard as a space that had once been occupied. We remember that King Arthur is said by legend to be buried nearby, that the light-house is like the one, or perhaps is the one, that Virginia Woolf's Mrs Ramsay promises upon, that Turner painted this landscape with such sublime attention that its light is now inseparable from the 'Turneresque'. The cows themselves, with stars marked on their foreheads and clouds emblazoned on their torsos, seem like the sombre priests of a charming solar religion. We 'people' the scene with meaning.

Nevertheless the fact of the eclipse remains: the fact that as we can never look at the sun, this one gap, this one break, could also give us a disarming illusion of accessibility that readily could blind us. We cannot see this event, indeed any event, from a noumenal point of view. And the certainty of the eventual disappearance of the sun – something that will happen irrevocably and irreversibly just a few million years from now – haunts our pleasure in the transitory aspect of this eclipse, as it haunts our pleasure in all human making. *Banewl* could not be more intensely tied to a moment in time and place, and yet it is truly a work of art on the threshold of eternity – the very eternity that, in lighting our world, bestows on us the temporary gift of blindness to its end.

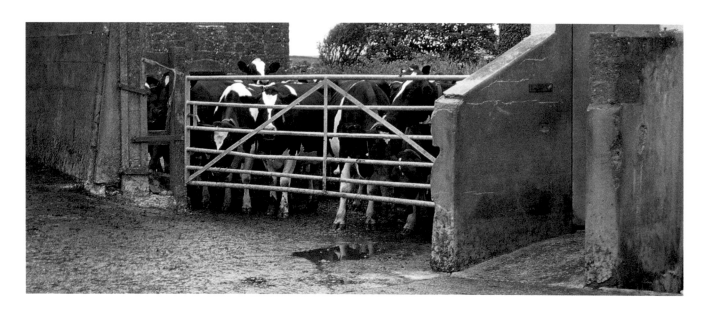

*Banewl* 1999, 16mm film still

# Fernsehturm

## FRIEDRICH MESCHEDE

Tacita Dean made her most recent work, which has the German title *Fernsehturm* (Television Tower), in Berlin in October 2000. But her interest in the tower began much earlier in life. As a student, back in 1987, she travelled to Berlin. When she crossed over into East Berlin, at that time still cut off from the western part of the city, the Fernsehturm was one of the places she visited. Now, returning to Berlin as a guest artist under the Berlin Artists' Programme, she remembered that earlier visit to the tower, decided to seek it out again as a vantage-point from which to view the whole city, and conceived the idea for the present film. A particular characteristic of the tower's restaurant is that it is on a circular revolving platform which turns 360 degrees every half hour, and during that time the visitor sitting there experiences one rotation and sees a complete panorama of the city. Ever since its completion in 1969, the Fernsehturm has dominated Alexanderplatz – the legendary place which achieved world-wide fame through Alfred Döblin's novel *Berlin Alexanderplatz* and the television film version by Rainer Werner Fassbinder. Its name has come to signify the quintessence of central Berlin. 365 m (1198 feet) tall, the Fernsehturm, designed by Hermann Henselmann, still stands visible from afar, as the emblem of Berlin's 'Mitte', the centre of the historic city.

It was the fact that the restaurant revolved inside the sphere near the top of the tower that attracted Dean and formed the basis for her idea. Using a static camera, she filmed the interior during the normal operation of the restaurant, and used the constantly shifting aspect to create a panorama of the changing light. All the formal elements of the setting confirm the logic of Dean's idea: the rotation of the disc inside the sphere suggests the notion of an ideal (as opposed to an actual) view. Also, the view may be considered ideal because, both externally and internally, the location has the geometric form of the sphere, a perfect form without beginning or end, and one which, at this height, affords a prospect which is similarly infinite.

This place with its boundless views invites us to dream. Visitors gaze in fascination across the city, trying to locate and identify familiar places down below, or else they let their eyes roam to faraway parts of Brandenburg. Each visitor falls silent as they're drawn into the view from the restaurant. Prior to the political upheavals which opened the borders, this place must have had an even greater impact, evoking melancholy reflections, because from here nothing seemed to stand between the viewer and the distant horizon.

The form of the Fernsehturm enables Tacita Dean to explore the subject of light, and for this reason the movement of the rotating restaurant is a mechanical necessity. The static camera is set up and focused in such a way as to take in the broadest possible sweep of the windows. At dusk, when the light of day yields to the darkness of night, it records the changes taking place on the 'screen' that stands between inside and outside. With the gradual changes in light caused by the Earth's rotation, the appearance of the interior space where the camera is standing also changes. The windows are at first transparent, giving a clear view to the horizon. Then against the light of the setting sun, they become translucent and everything becomes less and less sharply defined. Finally, as lights are gradually turned on inside, the window surfaces become screens that reflect the interior. With the final switching on of the electric lights, the interior space, which had previously appeared open and receptive towards the light, becomes a confined space surrounded by exterior darkness, and the windows now act as mirrors to the glare of the fluorescent lights.

During the process of this metamorphosis, the chance images which the film creates evoke a variety of momentary reminiscences familiar from art history. The visitors gazing out into the evening sun may resemble the *repoussoir* figures in Romantic paintings; sometimes the scene looks like a tableau based on a painting by Edward Hopper. A whole spectrum of such precursors from painting seem to cross one's inner eye and act as a kind of meditative accompaniment to the film itself.

In the work, Dean makes the horizontal sequence of the television tower's windows look like a strip of film, an effect reinforced by the turning movement of the restaurant and the extended frame of the anamorphic film format. The vertical

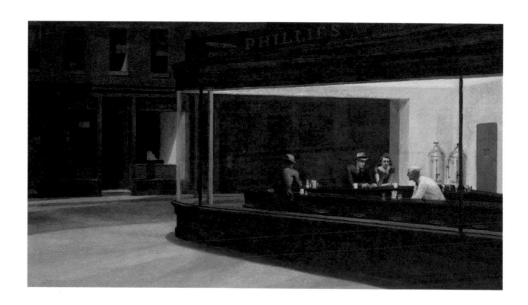

divisions between the windows are like the dark lines separating one photographic frame from the next. As attention is therefore deliberately drawn to the windows of this 'observation restaurant', its architectural form is made to seem like an essential formal element of the film. Just as a film consists of a sequence of frames, so here we have a sequence of windows, and this, being circular, appears to be unending. The viewer is suddenly unable to make out where or when the rotation begins or ends. There is a parallel between this revolving movement, which introduces the idea of infinity, and the phenomenon of light. Light changes in response to a higher order of things, namely the rotation of the Earth, and this recurs day after day because this rotation too has no beginning or end. As an anecdotal footnote, it is worth mentioning that in former times, the restaurant used to take an hour to rotate 360 degrees, but after the reunification of Germany the time taken for the full rotation was reduced, or the movement accelerated (depending on one's view) to 30 minutes. The concept of the *Fernsehturm*

film project is thus a metaphor for the contingent nature of seeing. We are given a unique visual experience in the specific form of a segment of a day, in this case the afternoon of 12 October 2000. On any other day the light would inevitably be different because of variations in weather conditions. Looking at it from this point of view – a source of much anxiety in the run-up to the shoot – the influence of mere chance was very considerable, and it could not be controlled in any way. Rather than chance, one may prefer to think of it in terms of the specific and unique, which can always be experienced anew.

Tacita Dean is an artist whose works always seek to make some connection with historical facts or circumstances, or are prompted by them. It is therefore legitimate to adduce such historical factors when interpreting the work, even if she herself has not directly and deliberately related the two. The period around 1920 saw the emergence in Berlin of visionary ideas on light and architecture, on articulating the immaterial as the expression of a 'New Architecture'. Ideas of this kind were

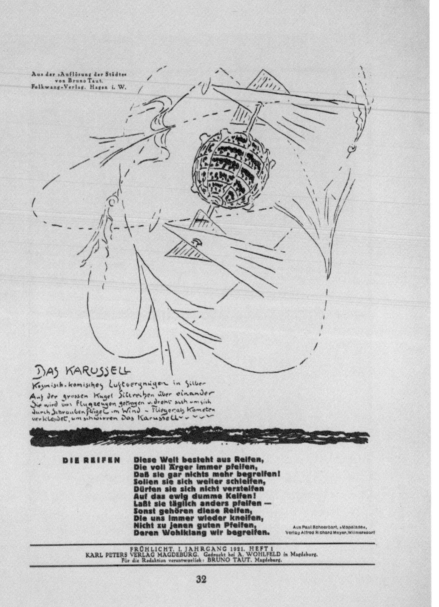

Aus der »Auflösung der Städte«
von Bruno Taut.
Folkwang-Verlag. Hagen i. W.

DAS KARUSSELL

Kosmisch-komisches Luftvergnügen in Silber

Auf der grossen Kugel Sitzreihen über einander
Sie wird von Flugzeugen getragen u. dreht sich um sich
durch Schraubenflügel im Wind – Flieger als Kometen
verkleidet, um schwirren Das Karussell.

**DIE REIFEN**  **Diese Welt besteht aus Reifen,**
**Die voll Ärger immer pfeifen,**
**Daß sie gar nichts mehr begreifen!**
**Sollen sie sich weiter schleifen,**
**Dürfen sie sich nicht versteifen**
**Auf das ewig dumme Keifen!**
**Laßt sie täglich anders pfeifen –**
**Sonst gehören diese Reifen,**
**Die uns immer wieder kneifen,**
**Nicht zu jenen guten Pfeifen,**
**Deren Wohlklang wir begreifen.**

Aus Paul Scheerbart, »Mopalades«,
Verlag Alfred Richard Meyer, Wilmersdorf

FRÜHLICHT. I. JAHRGANG 1921. HEFT 1
KARL PETERS VERLAG MAGDEBURG. Gedruckt bei A. WOHLFELD in Magdeburg.
Für die Redaktion verantwortlich: BRUNO TAUT, Magdeburg.

32

Colophon from the first issue of *Frühlicht* magazine, edited by Bruno Taut, 1921. The caption reads: 'A cosmic-comical aerial amusement in silver; the large sphere has rows of seats one above another; it is held up in the air by aeroplanes and rotates on its axis as the wind catches its propeller blades; aircraft disguised as comets dart around it.'

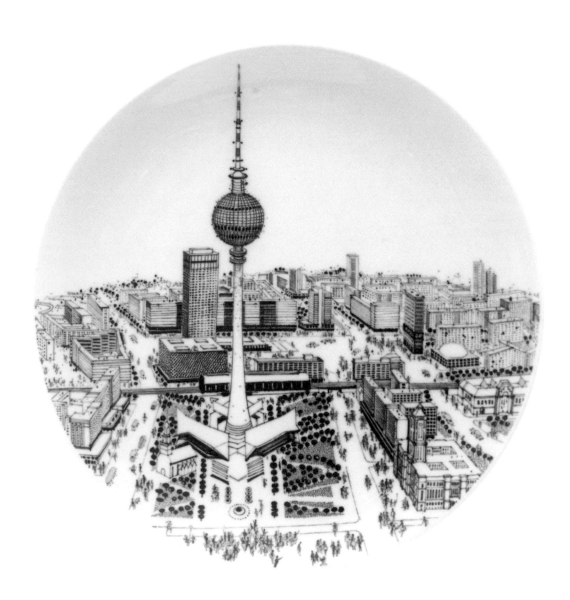

Meissen plate found by the artist in a Berlin fleamarket

developed by Bruno Taut and a group of architects and artists associated with him, who called themselves the *Gläserne Kette* (Glass Chain). Bruno Taut put forward his ideas in the journal *Frühlicht*, which ran only from 1920 to 1922. Before that, in 1914, *Der Sturm* had published the book *Glasarchitektur* (dedicated to Bruno Taut) by the writer Paul Scheerbart. Some young architects adopted the vision put forward in this utopian literary work as their guiding principle, and were inspired by it to design fantastical architecture that was never actually built. Through the linking of light and architecture, the Gothic cathedral became the historical model to follow, and was reinterpreted as an expression of such a link. The cathedral can be found as a motif representing the future in drawings by Bruno Taut and Hans Scharoun, as well as in Lyonel Feininger's famous title-page woodcut for the Bauhaus manifesto. In the same year, 1919, Bruno Taut published *Die Stadtkrone* where he envisioned a 'crystal palace' as the centre of the new city. Around 1920, Bruno Taut and his friends also worked on an idea for a film with no acting: instead, the subject was what could be achieved by the technical manipulation of light. The title of the project was *Die Galoschen des Glücks* (The Galoshes of Fortune).

Both Bruno Taut and Tacita Dean see the camera solely as an apparatus for achieving particular visual effects. Thus a central feature of *Fernsehturm* is its reliance on an extremely simple filming technique – the use of a static camera which simply records what takes place in front of it. Everything else is done by the continuous, mechanical rotation of the restaurant floor and by the Earth's rotation in accordance with the laws of cosmic physics. Though Hermann Henselmann's television tower can hardly be seen as an example of architecture embodying the principles of the *Gläserne Kette* group, nevertheless the crystalline treatment of the upper half of the sphere clearly shows the architect's desire to produce something akin to one of Bruno Taut's visions. In the early 1960s, when the reconstruction of Alexanderplatz was being planned, the political and ideological climate in the German Democratic Republic was certainly such as to encourage the visionary ideas of the 1920s to be incorporated into the design of showpiece architectural projects such as the tower.

Bruno Taut's ideas live on, transformed, in the Fernsehturm. When we look at the first issue of *Frühlicht* of 1921, and see the drawing on the back page showing an idea for a merry-go-round high up in the air, Henselmann's sphere seems directly inspired by Bruno Taut, and the idea of the merry-go-round has been realised in the revolving floor of the restaurant.

Undoubtedly *Fernsehturm* follows on in this tradition. However, in contrast to the social utopian ideals of city planning in the 1920s and 1960s, the film fits into the personal iconography of Tacita Dean's work to date: air, water, earth and light. The afternoon of 12 October 2000 was certainly blessed, and Tacita Dean succeeded in recording the light above Berlin for us to see.

'It was about twenty past one in the morning, and I was reading *The Taming of the Shrew* in bed, when suddenly all the windows blew in and the room was filled with a greenish dust. When I looked around, all the furniture had moved, not far, it had all just moved round about a foot.'

ABOVE A description of events that occurred during the bombing of London in 1940. *The Blitz*, Constantine Fitzgibbon, Macdonald, London 1970.

BELOW A photograph of one of the 150 bricks that constitute Raffael Rheinsberg's artwork *Bekannte–Unbekannte* 1980, (trans. Familiar–Unfamiliar). Rheinsberg collected the bricks from demolition sites in Berlin and each one shows a different maker's name or emblem. *Bekannte–Unbekannte*, Raffael Rheinsberg, Neuer Berliner Kunstverein 1980.

Page contributed by Mathew Hale

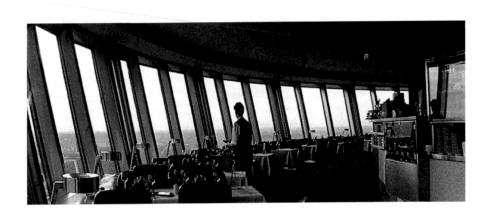

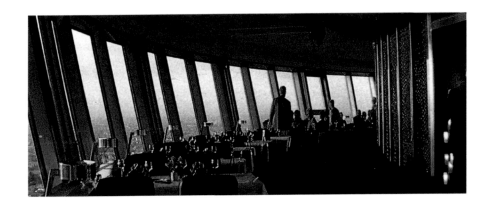

*Fernsehturm* 2001, 16mm film stills

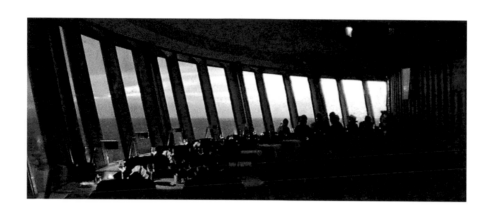

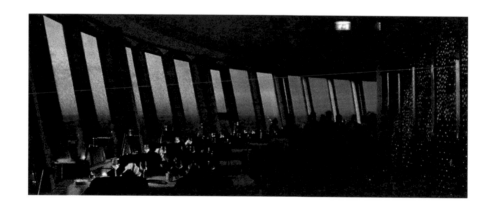

*Fernsehturm* 2001, location photograph

*Fernsehturm* 2001, location photograph

# The green ray

PETER NICHOLS

'We from the little ships see things not vouchsafed the ordinary traveler', wrote English sailing author Eric Hiscock in 1953. I liked the watery world of the 1930s, 40s and 50s that he described in fusty prose in his many books, and I read them all when I took to the sea almost thirty years ago. I tried to sail in Hiscock's wake in my own small, spartan wooden cutter that had been built in Paignton, Devon, in 1939.

One of the sights frequently vouchsafed Hiscock was the 'green flash'. This phenomenon can be observed at the last moment of sunset – technically the moment *after* the sun's upper rim disappears into the sea – when a green iridescent flash fans out over the horizon above the sunken orb. Or so Eric claimed. 'We, the seers of the green flash...', he wrote smugly of the yachting fraternity's privileged access to the rarest glories of nature.

But look and strain unblinking as I might, under seemingly perfect conditions in a decade spent entirely afloat, upon small seas and large oceans, I never once saw the green flash. I knew it existed, others have seen it, but I began to wonder about Eric's claims. It seemed that whenever he and his wife Susan sat down in their boat's cockpit for their sundown drink, they were quickly vouchsafed another fine, if fleeting, display. Yet elsewhere Hiscock had written of his poor eyesight: 'I have never been able to read ordinary print without the aid of a magnifying glass.' Photographs in his books show him wearing glasses with half-inch thick lenses. How could he have seen *anything*? Perhaps he was seeing spots before his eyes.

In time, my old yacht sank and I staggered ashore, shipwrecked and penniless. In rooms that did not exhibit a constant desire to sink, nor needed to be prevented from doing so by my constant efforts, I began to write about the sea.

A few years ago I went sailing with my sister and her husband, who were living aboard a large fibreglass yacht. It had everything my old boat hadn't, including television and good Italian marble in the bathrooms. I joined them in the Caribbean. Much had changed since my earlier days there. Anchorages were packed with plastic boats. Noisy traffic choked the shore roads. It was far from Hiscock's halcyon world.

One afternoon we pulled into a crowded harbour in Guadeloupe. It was hard to find a clear spot to drop the anchor in. Jet skis zoomed all around us, sending Chico, my brother-in-law's parrot, berserk. Chico bawled and screamed, the boat's generator rumbled beneath my feet, and I went and sat in the bow trying to find some peace. I stared out of the harbour's mouth and ached, as always, to be somewhere else. The sun was going down, and out of old habit, wholly devoid of expectation, I squinted and watched it settle into the clear sea horizon.

As the red upper rim vanished, a distinct, momentary, radium-green glow blinked and was gone.

'Did you see that?!', I yelled back at the cockpit.

An insane eldritch cackle ripped from Chico.

'Oh *shut up, Chico*!' snapped my sister.

And that was it.

Steinhuder Meer                                    144

Last summer I corresponded with Tacita Dean about a book I was writing, the true story of a sea race that went wrong for most of its competitors, which she has also written about. Tacita is keenly alive to the phenomena of the sea, and to our subjective experience of these. We wrote to each other about the green flash – the green ray she calls it.

Later, she sent me an old postcard in an envelope from Berlin. It's a black-and-white photograph of the Steinhuder Meer in northern Germany, at sunset, I choose to think; a very Hiscockian scene, the sort vouchsafed no one any more. It has an 8 Deutschemark stamp on the back and it was sent on 26 May 1930 to Frau Elisabeth Pohl in Berlin by Heinrich.

A glow of light is coming from the sun setting behind the land on the horizon – an obstruction precluding any possibility of seeing the green flash, as Tacita well knows. But she has washed green paint across the sky above the horizon and it's the perfect radium shade. Tacita's unblinking ray, the way I always imagined it.

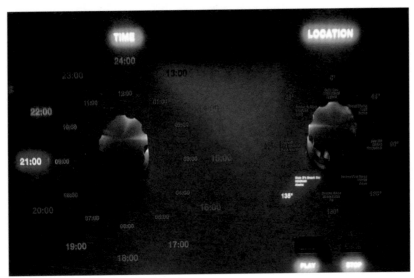

*Jukebox 1* 2000

*Waleed, Our Ministry of Information Official*
*Altawahi Souk, Aden, Yemen, Early Hours of the Morning* 2000
Black and white photograph, 60 × 90 cm

*Dixie D's Snack Bar*
*Hoonah, Alaska, Early Hours of the Morning* 2000
Colour photograph, 60 × 90 cm

# A practical approach to mapping time

SIMON CROWHURST

A few years after my father died, when I was aged about twelve, I saw something that made a strong connection in my mind between geological layers and the measurement of time. We were on a family visit to the beach at East Quantoxhead in Somerset. The cliffs are Blue Lias, continually eroded by the sea, and at one point a recent cliff fall had exposed the underside of a layer of limestone about three metres up the cliff. Several large fossil ammonites, each one a ridged spiral almost a metre across, were clustered as if interlocked on this freshly exposed plane of rock, set in the middle of the alternating shale and limestone bands. The powerful visual impression was of a layer of machinery, some ancient clockwork of the Earth laid bare, and it remains one of my most vivid childhood memories. Thirty years later, I have spent most of my working life analysing layers of rock, searching for the signals that they hold of the passage of geological time.

The truth is, we all spend our days blithely in the context of the ancient and the distant. The buildings around us are built from ancient sediments; even brick-built structures are made from clays that may have been walked on by dinosaurs, and that once wrapped their bones. The ground that we stand upon is an archive constituted of the distant past. The evolution of life is embodied in every face we see, each plant we walk by or eat, in our senses and to some extent in our thoughts. The atoms that compose us were assembled in distant stellar furnaces long ago. We are the products of processes that are in general so slow compared to our lives, that it makes scarcely any difference to the way we live if we are totally ignorant of them. It's like the joke about the optician's client; he complains that he can't see very far, so the optician takes him outside and points up. 'What's that?', he asks his visitor. 'The sun, of course', comes the reply. 'Exactly how far do you want to be able to see?'

Of course we need to operate within a human frame of distance and time. But in drawing the lines for that frame, we cannot help but notice that they stretch off into vast distances, like those between the stars. These are not like the circumscribed lines of latitude that circle the poles, or of longitude that run from pole to pole. The frame for our experience is set between timelines that stretch back into the millennia before history, before humans, and before life; and forward into the distant exhaustion of energy in space.

Our actual experience of time is necessarily highly localised. But our vision of the past, and to some extent also of the future, can potentially encompass a vast and distant panorama. We are small fish, a kind of plankton in the huge sea of time; but just occasionally we can look over the surface and glimpse a little of how vast an ocean we live in.

The scale of the distant past does not simply dwarf and ridicule the present; it can inform us, make us richer in understanding, and caution us with lessons about what might go wrong, where our home planet's sensitivities lie. It is a privilege to work in such a domain. My father, alone in a small boat and struggling for a metaphysical position, was in a sense lost in time, obsessed simultaneously with eternities and seconds. It doesn't do to be overawed by the expanse of time, or lost in its immeasurability. Just as a navigator can find his or her position on the Earth from the stars, we can learn something about where we are by the careful study of the traces of deep time. In the end, of course, it looks like time will swallow us and all our thoughts and works; but there's more to time than the joke of its enormity. If all we do is laugh, we may miss much of the beauty.

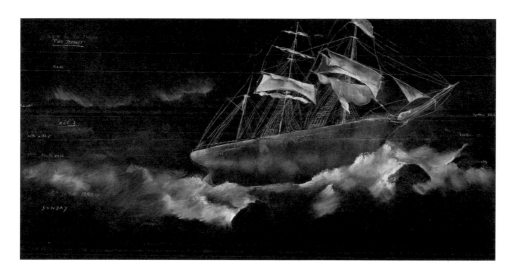

*The Sea, with a Ship; afterwards an Island* 1999
Blackboard drawings
Three parts, each 244 × 488 cm

*Czech Photos* (work in progress)
Black and white photograph (actual size)

# Chronology

1965    Born in Canterbury, Kent
1985–8    Falmouth School of Art, Falmouth
1989–90    Greek Government scholarship to the Supreme School of
     Fine Art, Athens
1990–92    The Slade School of Fine Art, University College London
1994    Barclays Young Artist Award, London
1995    Artist in Residence, Ecole Nationale de Beaux-Arts, Bourges
1997    Screenwriters' Lab, Sundance Institute, Sundance, Utah
1998    Shortlisted for the Turner Prize, Tate Gallery, London
1999    Artist in Residence, Wexner Center for the Arts, Columbus, Ohio
2000–1    DAAD Scholarship, Deutscher Akademischer Austauschdienst,
     Berlin

### SOLO EXHIBITIONS

1994    *The Martyrdom of St Agatha and Other Stories*, Galerija
     Skuc, Ljubljana & Umetnostna Galerija, Maribor, Slovenia
1995    *Clear Sky, Upper Air*, Frith Street Gallery, London
     *Tacita Dean*, Galerie 'La Box', Ecole Nationale de Beaux-Arts,
     Bourges
1996    *Foley Artist*, Art Now, Tate Gallery, London
1997    *Tacita Dean*, Witte de With, Center for Contemporary Art,
     Rotterdam
     *Tacita Dean*, The Drawing Room, The Drawing Center, New York
     *Tacita Dean*, Frith Street Gallery, London
1998    *Tacita Dean*, Galerie Gebauer, Berlin
     *Statements*, Frith Street Gallery, Art Basel '98
     *Tacita Dean*, De Pont Foundation, Tilburg
     *Tacita Dean*, Institute of Contemporary Art, University of
     Pennsylvania, Philadelphia
1999    *Tacita Dean*, Madison Art Center, Madison, Wisconsin
     *Tacita Dean*, Sadler's Wells Theatre, London
     *Tacita Dean*, Marian Goodman Gallery, Paris
     *Tacita Dean*, Cranbrook Museum, Bloomfield Hills, Michigan
     *The Sea, with a Ship; afterwards an Island*, Dundee Contemporary
     Arts, Dundee
     *Banewl*, Newlyn Art Gallery, Penzance
     *Millennium Sculpture Project*, London
2000    *Tacita Dean*, Marian Goodman Gallery, New York
     *Tacita Dean*, Museum für Gegenwartskunst, Basel
     *Tacita Dean*, Art Gallery of York University, Toronto
     *Banewl*, Matrix Program, Berkeley Art Museum, University of
     California, Berkeley
2001    *Tacita Dean*, Museu d'Art Contemporani de Barcelona, Barcelona
     *Tacita Dean*, Tate Britain, London

### GROUP EXHIBITIONS

1992    *BT New Contemporaries*, Newlyn Orion, Penzance; Cornerhouse,
     Manchester; Orpheus Gallery, Belfast; Angel Row & Bonnington
     Gallery, Nottingham; Institute of Contemporary Art, London
1993    *Barclays Young Artist Award*, Serpentine Gallery, London
     *Peripheral States*, Benjamin Rhodes Gallery, London
1994    *Watt*, Witte de With, Center for Contemporary Arts & Kunsthal,
     Rotterdam

     *Coming Up for Air*, 144 Charing Cross Road & the agency, London
     *Mise en Scène*, Institute of Contemporary Arts, London
1995    *Mysterium Alltag*, Hammoniale der Frauen, Kampnagel,
     Hamburg
     *Kine[kunst]'95*, Casino Knokke, Knokke-Heist
     *Video Forum*, Art Basel '95, Basel
     *Speaking of Sofas*, touring programme distributed by London
     Electronic Arts, London
     *Whistling Women*, Royal Festival Hall, London
     *Videos and Films by Artists*, Ateliers d'Artistes de la ville de
     Marseille, Marseille
     *The British Art Show 4*, National Touring Exhibition, organised by
     the Hayward Gallery for the Arts Council of England
     *Liesbeth Bik, Tacita Dean, Jos van der Pol, Peter Fillingham*, Cubitt
     Street Gallery, London
1996    *CCATV*, Centre for Contemporary Art, Glasgow
     Art Node Foundation, Stockholm
     *State of Mind*, Centrum Beeldende Kunst, Rotterdam
     *Swinging the Lead*, International Festival of the Sea, Bristol
     *Berwick Ramparts Project*, Berwick upon Tweed, Northumberland,
     organised by Northumberland County Council, Berwick upon
     Tweed Borough Council, English Heritage and Northern Arts
     *Container '96: Art Across Oceans*, Parkhus Quay, Copenhagen
     *Tacita Dean & Stephen Wilks*, Galerie Paul Andriesse, Amsterdam
     *Found Footage*, Klemens Gasser & Tanja Grunert, Cologne
1997    *Exploding Cinema*, 26th International Film Festival Rotterdam,
     Rotterdam
     *Challenge of Materials*, Science Museum, London
     *A Case for a Collection*, Towner Art Gallery, Eastbourne
     *Contemporary British Drawings – Marks & Traces*, Sandra Gering
     Gallery, New York
     *Celluloid Cave*, Thread Waxing Space, New York
     *Flexible*, Museum für Gegenwartskunst, Zurich
     *The Frame of Time – Openmuseum*, Museum van Hedendaagse
     Kunst, Limburg
     *Screenwriters' Lab*, Sundance Institute, Sundance, Utah
     *At One Remove*, Henry Moore Institute, Leeds
     *20:20*, Marian Goodman Gallery, New York
     *Social Space*, Marian Goodman Gallery, Paris
     *New Found Landscape*, Kerlin Gallery, Dublin
1998    *Voiceover: Sound and Vision in Current Art*, National Touring
     Exhibition organised by the Hayward Gallery for the Arts Council
     of England
     *Wounds: Between Democracy and Redemption in Contemporary Art*,
     Moderna Museet, Stockholm
     *A–Z*, The Approach, London
     *Video / Projection / Film*, Frith Street Gallery, London
     *La Terre est Ronde – Nouvelle Narration*, Musée de Rochechouart,
     Rochechouart
     *La Mer n'est pas la Terre*, FRAC Bretagne, La Criée, Rennes
     *Disrupting the Scene*, Cambridge Darkroom, Cambridge
     *Breaking Ground*, Marian Goodman Gallery, New York
     *Sharawedgi*, Felsenvilla, Baden
     *The NatWest Art Prize 1998*, Lothbury Gallery, London
     *The Turner Prize 1998*, Tate Gallery, London

1999    *New Media Projects*, Orchard Gallery, Derry
*Exploding Cinema*, 28th International Film Festival Rotterdam, Rotterdam
*1264–1999 Une Légende a Suivre*, Le Credac, Ivry
*Appliance of Science*, Frith Street Gallery, London
*Hot Air*, GranShip, Shizuoka Convention and Arts Center, Shizuoka
Marian Goodman Gallery, Paris
*Geschichten des Augenblicks*, Städitsche Galerie im Lenbachhaus, Munich
*Go Away: Artists and Travel*, Royal College of Art, London
*New Visions of the Sea*, National Maritime Museum, London
*Fourth Wall*, Public Art Development Trust at the Royal National Theatre, London
*0 to 60 in 10 Years*, Frith Street Gallery, London
*Laboratorium*, Antwerpen Open, Antwerp
*Un monde réel*, Fondation Cartier, Paris
*Tacita Dean, Lee Ranaldo, Robert Smithson*, Dia Center for the Arts, New York

2000    *Landscape*, ACC Gallerie, Weimar, international touring exhibition organised by The British Council
*The Sea and the Sky*, Beaver College Art Gallery, Philadelphia; Royal Hibernian Academy, Dublin
*L'ombra della ragione*, La Galleria d'Arte Moderna, Bologna
*Intelligence: New British Art 2000*, Tate Britain, London
*On the Edge of the Western World*, Yerba Buena Center for the Arts, San Francisco
*Amateur/Liebhaber*, Kunstmuseum, Kunsthallen & Hasselblad, Gothenberg
*Mixing Memory and Desire*, neues Kunstmuseum, Luzerne
*Artifice*, Deste Foundation, Athens, international touring exhibition organised by The British Council
*Somewhere Near Vada*, Project Art Centre, Dublin
*Another Place*, Tramway, Glasgow
*media_city Seoul 2000*, Seoul Metropolitan Museum, Seoul
*Tout le Temps*, La Biennale de Montréal, Montréal
*Vision and Reality*, Louisiana Museum of Art, Louisiana

2001    *Arcadia*, National Gallery of Canada, Ottawa
*Humid*, Spike Island, Bristol
*Nothing: Exploring Invisibilities*, Northern Gallery of Contemporary Art, Sunderland
*Double Vision*, Galerie für zeitgenoessische Kunst, Leipzig

SELECTED WRITINGS AND PUBLISHED
PROJECTS BY THE ARTIST

1995    *Clover*, Artist's Page in *General Release: Young British Artists at Scuola di San Pasquale*, London: The British Council
*Clover Book*, (artist's book), Bourges: Ecole Nationale de Beaux-Arts
*Galerie 'La Box'*, Bourges: Ecole Nationale de Beaux-Arts

1997    Cahier No.6, Rotterdam: Witte de With, Center for Contemporary Art
'Tacita Dean – Insert with Blackboard Drawings', *Parkett*, No. 50/51
*Disappearance at Sea: A Book of Blackboard Drawings*, Limoges: Edition Adelie, Limoges and Ecole Nationale de Bourges with the support of the British Council, 1997. Signed edition of 100

1999    *Teignmouth Electron*, London: Book Works in association with the National Maritime Museum, Greenwich

2001    *Floh*, (made in collaboration with Martyn Ridgewell), Steidl Verlag

SOLO EXHIBITION CATALOGUES

1995    *Tacita Dean*, Bourges: Ecole Nationale des Beaux-Arts
1996    *Foley Artist*, London: Tate Gallery
1997    *Missing Narratives*, Rotterdam: Witte de With Center for Contemporary Art
1998    *Tacita Dean*, Philadelphia: Institute of Contemporary Art, University of Pennsylvania
2000    *Tacita Dean*, Basel: Museum für Gegenwartskunst
2001    *Tacita Dean*, Barcelona: Museu d'Art Contemporani de Barcelona

OTHER PUBLICATIONS

1992    *BT New Contemporaries*, Halifax: New Contemporaries
1993    *Barclays Young Artist Award*, London: Serpentine Gallery
1994    *Cahier No. 2*, Rotterdam: Witte de With, Center for Contemporary Art
*Mise en Scène*, London: Institute of Contemporary Art
1995    *Mysterium Alltag*, Hamburg: Kampnagel
*Directory of British Film and Video Artists*, London: Arts Council of England
*The British Art Show 4*, London: National Touring Exhibition, South Bank Centre
1996    *Berwick Ramparts Project*, Berwick upon Tweed: Nothumberland County Council, Berwick upon Tweed Borough Council, English Heritage, and Northern Arts
*Container '96: Art Across Oceans*, Copenhagen: Copenhagen Cultural Capital Foundation
*Swinging the Lead*, Bristol: International Festival of the Sea
1997    *At One Remove*, Leeds: Henry Moore Institute
*Cahier No. 6*, Rotterdam: Witte de With, Center for Contemporary Art
*Flexible*, Zurich: Museum für Gegenwartskunst
1998    *Cahier No. 7*, Rotterdam: Witte de With, Center for Contemporary Art
*Voiceover: Sound and Vision in Current Art*, London: National Touring Exhibitions, South Bank Centre
*The NatWest Art Prize 1998*, London: NatWest Group
*The Turner Prize 1998*, London: Tate Gallery
*Cream: Contemporary Art in Culture*, London: Phaidon Press
*Wounds: Between Democracy and Redemption in Contemporary Art*, Stockholm: Moderna Museet
1999    *Geschichten des Augenblicks*, Munich: Lenbachhaus München and Hatje Cantz
*Hot Air*, Shizuoka: GranShip Convention and Arts Center
*From A to B (and Back Again)*, a publication to accompany the exhibition *Go Away: Artists and Travel*, Royal College of Art Galleries, London: Pale Green Press
2000    *Landscape*, London: The British Council
*The Sea and the Sky*, Philadelphia: Beaver College Art Gallery; Dublin: Royal Hibernian Academy

*L'ombra della ragione*, Bologna: La Galleria d'Arte Moderna
*Intelligence: New British Art 2000*, London: Tate
*Amateur/Liebhaber*, Gothenberg: Kunstmuseum, Kunsthallen &
Hasselblad
*Mixing Memory and Desire*, Luzerne: neues Kunstmuseum
*Artifice*, London: The British Council
*Somewhere Near Vada*, Dublin: Project Art Centre
*media_city Seoul 2000*, Seoul: Seoul Metropolitan Museum
*Vision and Reality*, Louisiana: Louisiana Museum of Art

2001    *Arcadia*, Ottawa: National Gallery of Canada

SELECTED PERIODICAL AND NEWSPAPER ARTICLES

Anson, Libby, 'Tim Head/Tacita Dean', *Art Monthly*, No. 188,
July–August 1995, pp. 35–6

Ashbee, Brian, 'Artists Film and Video Part 1', *Art Review*, Vol. 51,
February 1999, pp. 60–1

Brownrigg, Silvia, 'Interview with a Dead Deceiver', *Frieze*,
March–April 1998, pp. 70–2

Coleman, Nick, 'The Wooster Street Mystery', *Independent*,
18 March 2000

Colin, Beatrice, 'Chalk One Up for Light Fantastic', *Sunday Times
Ecosse*, 19 September 1999

Cork, Richard, 'Pioneer with a Gender Agenda', *The Times*,
15 November 1994

Cork, Richard, 'Out with a chop, whir and clunk, review of "Foley
Artist"', *The Times*, 3 September 1996

Cruz, Juan, 'Disrupting the Scene', *Contemporary Visual Arts*,
Issue 21, p. 76

Dean, Tacita, 'Zen and the Art of Film Making', *Guardian*,
15 October 1997

Dean, Tacita, 'The Time of Our Lives', *Guardian*, 6 January 1999

Deepwell, Katy, 'Uncanny Resemblances', *Women's Art Journal*,
No. 62, January/February 1995

Del Re, Gianmarco, 'Tacita Dean: Tate Gallery', *Flash Art*, May/June
1997, p. 115

Del Re, Gianmarco, 'Cinema and the Sublime', *Contemporary Visual
Arts*, Issue 19, Summer 1998, pp. 40–7

Dorment, Richard, 'A masterly exercise in sadism', *Daily Telegraph*,
4 November 1998

Ebner, Jörn, 'Aus Frankensteins Genlabor', *Frankfurter Allgemeine
Zeitung*, 18 October 1997, p. 42

Feldman, Melissa E., 'Review of Foley Artist', *Art Monthly*, October
1996, p. 53

Grant, Simon, 'Coming up for Air', *Art Monthly*, May 1994

Greenberg, Sarah, 'Berwick Ramparts Project', *Art Monthly*,
September 1996, pp. 43–5

Greenberg, Sarah, 'Art Now: Tacita Dean/Focus on New art', *tate*,
Issue 10, Winter 1996

Higgie, Jennifer, 'Tacita Dean: Tate Gallery, London', *Frieze*,
November/December 1996, pp. 70–1

Hunt, Ian, 'Mise en Scène', *Frieze*, January/February 1995

Irvine, Jaki, 'Mise en Scène', *Third Text*, No. 30, Spring 1995,
pp. 101–106

Jeffett, William, 'Tacita Dean', *Contemporary Visual Arts*, Issue 17,
p. 77

Jones, Jonathan, 'Tacita Dean: Tate Gallery, London,' *Untitled*,
No. 12, Winter 1996, p. 24

Jones, Jonathan, 'Is That a Joke', *Guardian*, 4 November 1999

Kent, Sarah, 'Role Call', *Time Out (London)*, 26 October–
2 November 1994

Kent, Sarah, 'Sound Gallery Preview', *Time Out*, 26 August–
3 September 1996

Lütticken, Sven, 'Borsten van Sint Agatha', *Het Parool*, 2 August
1996

Mahoney, Elizabeth, 'Storm Warning', *Scotland on Sunday*,
12 September 1999

Phillips, Andrea, 'BT New Contemporaries, Barclays Young Artist
Award Exhibition', *Hybrid Magazine*, Issue 2, April/May 1993

Richard, Frances, 'Tacita Dean, The Drawing Room, NY', *Artforum*,
November 1997, p. 116

Schiff, Hajo, 'Elefantendung und die Brüste der Agathe', *Inhalt*,
March 1995, p. 88

Schwabsky, Barry, 'The Art of Tacita Dean', *Artforum*, March 1999,
pp. 98–101

Searle, Adrian, 'Behind the Mask', *Independent*, 25 October 1994

Searle, Adrian, 'People say nothing happens in Berwick…',
*Guardian*, 23 July 1996

Searle, Adrian, 'Noises Off', *Guardian*, 27 August 1996, p. 9

Searle, Adrian, 'Thick and Thin', *Guardian*, 8 July 2000

Smith, Roberta, 'Drawing that Pushes Beyond the Boundaries',
*New York Times*, 21 March 1997

Smith, Roberta, 'The Celluloid Cave', *New York Times*, 27 June
1997

Smith, Roberta, 'Rewards of Visiting Uptown Galleries', *New York
Times*, 28 November 1997

Smith, Roberta, 'Tacita Dean, Maurizio Cattelan', *New York Times*,
17 March 2000

Süto, W., 'De borsten van de heilige', *De Volkskrant*, August 1996

Swenson, Ingrid, 'A Lighthouse and Some Tapdancing: All in a Day's
Work', *Make: The Magazine of Women's Art*, October/November
1996 No. 72, pp. 14–16

Thompson, Martin, 'Misfit Lost in Time and Space (Martin
Thompson meets T. Dean and Donald Crowhurst's son)',
*Sunday Telegraph*, 28 March 1999, p. 7

Thrift, Julia, 'Beards, Breasts and Bloody Bodies', *Guardian*,
22 January 1993

Van den Boogerd, 'Dominic; It's Real, but Very Fucked Up',
*Metropolis M*, No. 2, 1994

Walsh, Maria, 'Beyond the Lighthouse: A Reflection on Two Films
by Tacita Dean', *Coil*, Issue 6, June 1998

Walsh, Maria, 'Tacita Dean', *Art Monthly*, June 1999, pp. 24–5

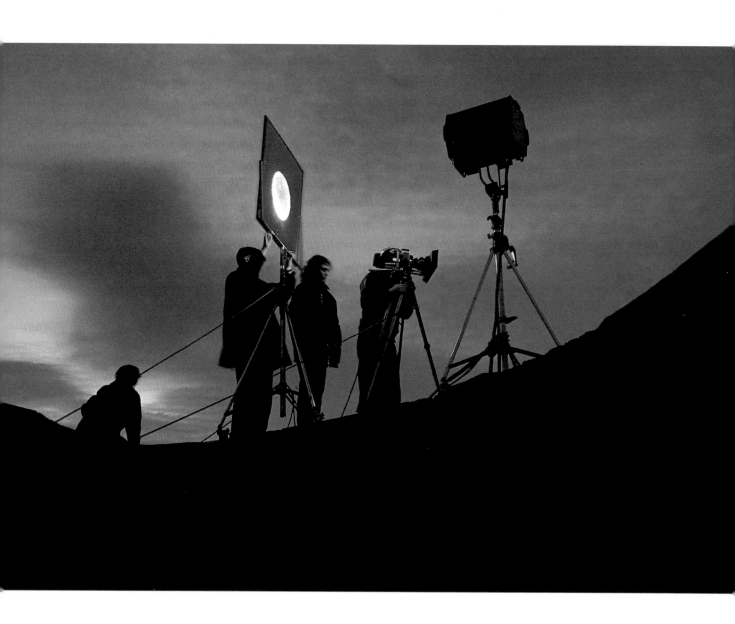

On location, filming *Disappearance at Sea*, Berwickshire, 1996

# Filmography & sound works

**The Story of Beard** 1992
16mm colour and black and white, optical sound,
    voice-over, 8 minutes

Cast: Lucy Gunning, Robert Barr, Tacita Dean, Philip
    Jones, Jo Lawrance, Christina McBride, Jeanie
    O'Hare, Craig Peacock, Julia Thrift, Sara Wicks
Camera: Tacita Dean, Christina McBride, Julia Thrift
Music: Philip Jones
Optical Printing: Nick Collins
Sound Transfer: Steve Felton
Stills: Jeanie O'Hare
Neg cut: Trucut
Printed by Filmatic
Filmed on location in Prague, Kent and London
Supported by the Ray Finnis Charitable Trust and
    the Slade School of Fine Art

**The Martyrdom of St Agatha** (in several parts)
    1994
16mm colour, optical sound, voice-over, 14 minutes

Cast: Iris Athanasoula, Lucy Gunning, Jo Lawrance,
    Christina McBride, Jeanie O'Hare, Julia Thrift,
    Emma Tod
Camera: John Adderley, Tacita Dean
Camera Assistants: Jamie Cairney, Sara Wicks
Sound Assistants: Tom Wright, Steve C. Owen
Music: Mavernie Cunningham, Mark Pharoah,
    Warwick, Dominic Weeks
Sound Transfer: Steve Felton
Breast Casting: Rod Dickinson, Sara Wicks
Titles: Stuart Crundwell
With thanks to Katy English, Tim Hodgkinson, Philip
    Jones, Lorraine Miller, Craig Peacock, Martyn
    Ridgewell, Guy Sherwin, Helen Underwood
Edited at Four Corners
Dubbed by Warwick Sound
Neg cut: Triad
Printed by Rank Film Laboratories
Filmed on location in Catania, Sicily;
    Wolverhampton Iron Founders; London
Supported by the Arts Council of England

**Girl Stowaway** 1994
16mm colour and black and white, optical sound,
8 minutes

Cast: Monica Cariani, Aldo Anselmo, Nick Breese,
    David Luck
Camera: Tacita Dean
Sound Transfer: Steve Felton
With thanks to John Adderley, Marcus Davies,
    Martyn Ridgewell
Edited at Four Corners

Dubbed by Warwick Sound
Neg cut: Triad
Printed by Rank Film Laboratories
Filmed on location in Cornwall and Starehole Bay,
    Devon
Supported by the London Arts Board

**How to put a Boat in a Bottle** 1995
Video, colour with sound, 18 minutes

Cast: Jimmy Benny, Dorcas Benny, Tacita Dean,
    Helen Thompson
Camera: Tacita Dean
With thanks to David Luck, Gilles Martinez, Owen
    Oppenheimer
Filmed on location in St Ives, Cornwall
Edited at Ecole National des Beaux-Arts de Bourges

**A Bag of Air** 1995
16mm black and white, optical sound, voice-over,
3 minutes

Cast: Anthony Busi
Hot Air Balloon: Bruno Guérin, Patrick Poussardin
Camera: Tacita Dean
Sound Transfer: Steve Felton
With thanks to John Adderley, Sâadane Afif, Jean
    Frémiot, Vanessa Notley, Anna Selander, Brian R.
    Smith, Penny Tyler
Edited at Four Corners
Dubbed by Warwick Sound
Neg cut: Triad
Printed by Rank Film Laboratories
Filmed on location in the sky above Lans en Vercors
Supported by the Ecole National des Beaux-Arts de
    Bourges & Fonds Régional d'Art Contemporain
    du Centre

**Disappearance at Sea** 1996
16mm colour anamorphic, optical sound,
    14 minutes

Camera: John Adderley
Sound Transfer: Steve Felton
With thanks to Jamie Bennett, Pippa Coles, Helen
    Davidson, Ian Fairnington, Thomas Stewart
Anamorphic lens loaned by Joe Duntan
Edited at Four Corners
Dubbed by Warwick Sound
Neg cut: Triad
Printed by Rank Film Laboratories
Filmed on location at St Abb's Head, Berwickshire
Made for *Berwick Ramparts Project* 1996

**Delft Hydraulics** 1996
16mm black and white, optical sound, 3 minutes

Camera: Tacita Dean
Sound Assistant: Esther Boender, Roland
    Groenenboom
Sound Transfer: Steve Felton
Edited at Four Corners
Dubbed by Studiosound
Neg cut: Triad
Printed by Rank Film Laboratories
Filmed on location at Delft Hydraulics, De Voorst,
    The Netherlands

**Foley Artist** 1996
Laserdisc and monitor, eight speakers, Akai DD8
    playback machine, Sondor magnetic playback
    machine, dubbing chart lightbox

Actor: Tim Pigott-Smith
Foley Artists: Stan Fiferman, Beryl Mortimer
Camera: John Adderley
Clapper: Pip Laurenson
Sound Editor: Martin Cantwell
Technical Advisor: Mike Dowson
Production Supervisor: Steve Felton
Editor: Rob Wright
Sound Post Production: The Sound Design Company
Stills Photographer: Stephen White
On-line: Evolutions Television Ltd
Filmed on location at Delta Sound, Shepperton
    Studios
Made for *Art Now*, Tate Gallery, London

**Disappearance at Sea II**
**(Voyage de Guérison)** 1997
16mm colour anamorphic, optical sound, 4 minutes

Camera: John Adderley
Lighthouse Music: Ian Stonehouse
Sound Transfer: Steve Felton
With thanks to Jamie Bennett, Pippa Coles, Helen
    Davidson, Ian Fairnington, Thomas Stewart
Anamorphic lens loaned by Joe Duntan
Edited at Four Corners
Dubbed by Warwick Sound
Neg cut: Triad
Printed by Colour Film Services
Filmed on location at the Longstone Lighthouse,
    Farne Islands, Northumberland

**Trying to find the Spiral Jetty** 1997
Audio CD, 27 minutes

With Tacita Dean, Gregory Sax
Sound Editor: Tacita Dean
Digital Sound Post Production: The Sound Design
    Company
With thanks to Steve Felton, Sandra Portman
Recorded on location at Rozel Point, Great Salt
    Lake, Utah

**The Structure of Ice** 1997
16mm colour, optical sound, voice-over,
    3 minutes

Camera: John Adderley
Camera Assistant: Sam McCourt
Sound Transfer: Steve Felton
With thanks to Clare Cumberlidge, Rhona Garvin,
    Peter Morris, Nicola Perrin
Edited at Four Corners
Dubbed by Warwick Sound
Neg cut: Triad
Printed by Colour Film Services
Filmed on location at Blythe House, London
Made for *The Challenge of Materials Gallery*,
    Science Museum, London

**Gellért** 1998
16mm colour, optical sound, 6 minutes

Camera: Tacita Dean
Assistants: Heidi Kellokoski, Fatime Plótár, Márta
    Radnóti, Sabina Lang
Sound Transfer: Steve Felton
With thanks to John Adderley, Barnabas Bencsik,
    Mathew Hale, Pip Laurenson
Edited at Four Corners
Dubbed by Worldwide Sound
Neg cut: Triad
Printed by Colour Film Services
Filmed on location at the Gellért Baths, Budapest,
    Hungary
Made during the *In and Out of Touch*
    London/Budapest Exchange Programme

**Bubble House** 1999
16mm colour, optical sound, 7 minutes

Camera: Tacita Dean
Assistant: Kjetil Berge
Sound Transfer: Four Corners
With thanks to John Adderley
Edited at Four Corners
Dubbed by Worldwide Sound

Optical Sound Transfer: Martin Sawyer Sound
    Services
Neg cut: TKT Film Services
Printed by Metrocolour
Filmed on location on Cayman Brac

**Sound Mirrors** 1999
16mm black and white, optical sound, 7 minutes

Camera: Tacita Dean
Assistants: Mathew Hale, Maya Orme, Myles Orme,
    Ryan Orme
Sound Editor: Paul Hill
Digital Sound Post Production: Wexner Center
    Media Arts Program
With thanks to John Adderley, Steve Felton and
    Julie Crowe
Edited at Four Corners
Optical sound transfer: Martin Sawyer Sound Services
Neg cut: TKT Film Services
Printed by Metrocolour
Filmed on location at Denge Sound Mirrors in Kent
Made for the Public Art Development Trust *Fourth
    Wall* Project, The National Theatre, London

**From Columbus, Ohio to the Partially Buried
    Woodshed** 1999
Video, colour with sound, 9 minutes

With Tacita Dean, Paul Hill, Maria Troy
Camera: Paul Hill
Editor: Paul Hill
Post Production: Wexner Center Media Arts
    Program
Filmed on location on or near the site of Robert
    Smithson's *Partially Buried Woodshed*
Film of *Partially Buried Woodshed* 1970: Collection
    of the Wexner Center for the Arts, The Ohio State
    University, Columbus, Ohio. Gift of Robert Swick.
    Filmed by Leonard Henzel and Robert Swick
Supported by the Wexner Center Media Arts
    Program, The Ohio State University

**Banewl** 1999
16mm colour anamorphic, optical sound,
    63 minutes

Assistant Director: Mathew Hale
Director of Photography: John Adderley
Camera Operators: Jamie Cairney, Nick MacRae,
    Tom Wright
Clapper Loaders: Chris Connatty, Sam McCourt
Sun Tracking Motion Control: Michael Geissler,
    Lucien Kennedy-Lamb, Mark Seaton from
    Tronbrook Ltd

Anamorphic lenses loaned by Joe Duntan, with
    thanks to Mason Cardiff
Arriflex loaned by Arri GB Ltd, with thanks to Alan
    Fyfe
ACL Camera and Magazines loaned by Graeme
    Stubbings and Simon Sturtees
Sound Recordists: Camden Logan, Sara Sender
Digital Sound Post Production: The Sound Design
    Company
Sound Editor: James Harrison
Runners: Katy English, Rose Lord, Emily Whittle
Pinhole Research and Stills Photography: Richard
    Torchia
Eclipse Photography Consultant: Francisco Diego
Catering: Katy English
Barbecue: Blaise Vasseur, Lewis Horsman
With thanks to Emma Tod and Guy Waddell, Angela
    Adderley, Steve Felton, Anya Gallaccio, Martyn
    Ridgewell
With special thanks to Norman Truscott; the
    cowman, Andrew Marment and Roger Eddy for
    the loan of the cockerels; Ian Stuart for his
    advice on the local weather; Blue and David and
    Helen Hosking for helping us film Burnewhall
    Farm and their Pengwarnon Herd of Pedigree
    Holstein Friesians
Edited at Four Corners
Neg cut: TKT Film Services
Optical Sound Transfer: Martin Sawyer Sound Services
Printed by Metrocolour
Originated in Kodak Motion Picture Film
Filmed during the total eclipse of the sun at
    Burnewhall Farm, St Buryan, Cornwall,
    11 August 1999
Commissioned by St Ives International for *As Dark
    As Light* 1999 with thanks to Katy Sender
Supported by The National Lottery through The
    Arts Council of England, Visual Arts Department
    of the Arts Council of England, South West Arts,
    South West Media Development Agency,
    Elephant Trust, Henry Moore Foundation,
    Frith Street Gallery, London, Marian Goodman
    Gallery, New York

**Friday/Saturday** 1999
Akai DD8 Digital Dubber, 8 ARX Climate 6s
    speakers, Wharton Timecode Generator, MSF
    Radio receiver synched to the Rugby Atomic
    Clock, four 18 Gybyte Rorke data disk drives, eight
    24 hour soundtracks, eight description panels
Sound Recordings: Julie Crowe, Tacita Dean, Steve
    Felton, Mathew Hale, Christina McBride, Craig
    Peacock
Sound Editor: James Harrison

Digital Sound Post Production: The Sound Design
   Company
System Design: Feltech Electronics Ltd, with thanks
   to Guy Gampell
Signwriter: Danny Rogers of Studioart
With thanks to Andrea Schlieker
Sound recorded on location in Greenwich, England;
   Ubatuba, Brazil; New Orleans, USA; Hoonah,
   Alaska; Naselesele, Fiji; Akashi, Japan; Dhaka,
   Bangladesh; Aden, Yemen
Commissioned by The New Millennium Experience
   Company as part of *The North Meadows Project*,
   Millennium Dome, London
Photos: Tacita Dean, Mathew Hale

**Teignmouth Electron** 2000
16mm colour, optical sound, 7 minutes

Camera: Tacita Dean
Assistant: Kjetil Berge
Sound Editor: James Harrison
Digital Sound Post Production: The Sound Design
   Company
With thanks to John Adderley, Steve Felton, David
   Spence, National Maritime Museum, Greenwich
Edited at Four Corners
Dubbed by Worldwide Sound
Optical Sound Transfer: Martin Sawyer Sound Services
Neg cut: TKT Film Services
Printed by Metrocolour
Filmed on location on Cayman Brac

**Totality** 2000
16mm colour anamorphic, mute, 11 minutes

Assistant Director: Mathew Hale
Director of Photography: John Adderley
Camera Operators: Jamie Cairney, Nick MacRae,
   Tom Wright
Clapper Loaders: Chris Connatty, Sam McCourt
Sun Tracking Motion Control: Michael Geissler,
   Lucien Kennedy-Lamb, Mark Seaton from
   Tronbrook Ltd
Anamorphic Lenses loaned by Joe Duntan, with
   thanks to Mason Cardiff
Arriflex loaned by Arri GB Ltd, with thanks to Alan
   Fyfe

ACL Camera and Magazines loaned by Graeme
   Stubbings and Simon Sturtees
Runners: Katy English, Rose Lord, Emily Whittle
Pinhole Research and Stills Photography: Richard
   Torchia
Eclipse Photography Consultant: Francisco Diego
Catering: Katy English
Barbecue: Blaise Vasseur, Lewis Horsman
With thanks to Emma Tod and Guy Waddell, Angela
   Adderley, Steve Felton, Anya Gallaccio, Martyn
   Ridgewell
With special thanks to Norman Truscott, Ian Stuart,
   David and Helen Hosking
Edited at Four Corners
Neg cut: TKT Film Services
Printed by Metrocolour
Originated in Kodak Motion Picture Film
Filmed during the total eclipse of the sun at
   Burnewhall Farm, St Buryan, Cornwall,
   11 August 1999

**Jukebox 1** 2000
1 console, 3 CD changing mechanisms, 192 CDs,
   4 speakers

Project Manager: Michael Geissler from
   Tronbrook Ltd
Digital Sound Post Production Manager: Steve
   Felton from The Sound Design Company
Digital Sound Post Production: James Harrison
   from The Sound Design Company
Electronics & Programming: Stuart Willcocks from
   Tronbrook Ltd
Console Design and Fabrication: Gary Hudson
Fabrication Assistant: Miles Speak
Control Panel Design: Mathew Hale with Society
Control Panel Fabrication: K2 and Hamar Acrylic
CD Player Mechanism: Sound Leisure Ltd
With thanks to Complete Fabrication Ltd and
   Mark Seaton

**Jukebox 2** 2001
1 console, 3 CD changing mechanisms, 192 CDs,
   4 speakers

Digital Sound Post Production Manager: Steve
   Felton from The Sound Design Company

Digital Sound Post Production: James Harrison
   from The Sound Design Company
Electronics & Programming: Stuart Willcocks
Console Design and Fabrication: Gary Hudson
Fabrication Assistants: Miles Speak, Niall Stuckfield
Control Panel Design: Mathew Hale with Society
Control Panel Fabrication: K2 and Hamar Acrylic
CD Player Mechanism: Sound Leisure Ltd
With thanks to Complete Fabrication Ltd; Michael
   Geissler and Mark Seaton from Tronbrook Ltd

**Fernsehturm** 2001
16mm colour anamorphic, optical sound,
   44 minutes

Assistant Director: Mathew Hale
Director of Photography: John Adderley
Camera Operators: Jamie Cairney, Tom Wright
Clapper Loader: Chris Connatty
Anamorphic Lenses loaned by Joe Duntan
Project Co-ordinator: Friedrich Meschede
Locations Manager: Rüdiger Lange
Locations Assistant: Bettina Springer
With thanks to the staff and guests of the
   Fernsehturm especially Herr Wellner, Heinz
   Schulz and Hans Jurczik
Keyboard Player: Jo Larisch
Additional German Dialogue: Karin Fiedler, Friedrich
   Meschede
Sound Editor: James Harrison
Foley Artist: Paula Boram
Foley Mixers: Dave Tyler, Edward Colyer
Digital Sound Post Production: The Sound Design
   Company
With thanks to Steve Felton
Edited at Thomas Geyer Filmproduktion
Neg cut: TKT Film Services
Printed by Soho Images
Originated on Kodak Motion Picture Film
Supported by Tate; Frith Street Gallery, London;
   Marian Goodman, New York; Berliner
   Künstlerprogramm/DAAD

# List of exhibited works

*Disappearance at Sea* 1996
16mm colour anamorphic film with optical sound, 14 minutes
Tate

*Delft Hydraulics* 1996
16mm black and white film with optical sound, 3 minutes
Courtesy the artist, Frith Street Gallery, London and
Marian Goodman Gallery, New York/Paris

*Foley Artist* 1996
Laserdisc and monitor, eight speakers, Akai DD8 playback machine,
Sondor magnetic playback machine, dubbing chart lightbox
Courtesy the artist, Frith Street Gallery, London and
Marian Goodman Gallery, New York/Paris

*Disappearance at Sea II (Voyage de Guérison)* 1997
16mm colour anamorphic film with optical sound, 4 minutes
Courtesy the artist, Frith Street Gallery, London and
Marian Goodman Gallery, New York/Paris

*Trying to find the Spiral Jetty* 1997
Audio CD, 27 minutes
Courtesy the artist, Frith Street Gallery, London and
Marian Goodman Gallery, New York/Paris

*Mosquito (Magnetic)* 1997
16mm magnetic tape and chinagraph
9.5 × 428 cm
The British Council

*Teignmouth Electron* 1999
Black and white photograph
136 × 101 cm
Courtesy the artist, Frith Street Gallery, London and
Marian Goodman Gallery, New York/Paris

*Bubble House* 1999
16mm colour film with optical sound, 7 minutes
Courtesy the artist, Frith Street Gallery, London and
Marian Goodman Gallery, New York/Paris

*Sound Mirrors* 1999
16mm black and white film with optical sound, 7 minutes
Courtesy the artist, Frith Street Gallery, London and
Marian Goodman Gallery, New York/Paris

*Banewl* 1999
16mm colour anamorphic film with optical sound, 63 minutes
Courtesy the artist, Frith Street Gallery, London and
Marian Goodman Gallery, New York/Paris

*The Sea, with a Ship; afterwards an Island* 1999
Blackboard drawings
Three parts, each 244 × 488 cm
Emanuel Hoffmann Foundation, permanent loan to the
Museum für Gegenwartskunst, Basel

*Teignmouth Electron* 2000
16mm colour film with optical sound, 7 minutes
Courtesy the artist, Frith Street Gallery, London and
Marian Goodman Gallery, New York/Paris

*Jukebox 1* 2000
1 console, 3 CD changing mechanisms, 192 CDs, 4 speakers
Emanuel Hoffmann Foundation, permanent loan to the
Museum für Gegenwartskunst, Basel

*Fernsehturm* 2001
16mm colour anamorphic film with optical sound, 44 minutes
Courtesy the artist, Frith Street Gallery, London and
Marian Goodman Gallery, New York/Paris

# Acknowledgements

The artist would like to thank John Adderley, Steve Felton and The Sound Design Co., and Martyn Ridgewell for their longstanding commitment and help over many years in the making of various works; Gary Hudson and Stuart Willcocks for their energy and invention in the manufacture of the 'Jukebox'; Michael Geissler and Mark Seaton from Tronbrook Ltd for enabling the idea to go ahead in the first place; Sue MacDiarmid for all her hard work installing the show and Pip Laurenson for her technical advice generally; Dr Theodora Vischer and Heidi Naef for presenting the work so beautifully in the Museum für Gegenwartskunst in Basel in May 2000 which formed the starting point for this show; Dr Friedrich Meschede for all his help in Berlin; Simon Crowhurst for our continuing dialogue; Jane Hamlyn, Rose Lord, Johanna Wistrom and Dale McFarland from Frith Street Gallery, London for their inspired help and support, especially over the last year; Marian Goodman, Agnes Fiérobe and everyone at Marian Goodman Gallery, New York/Paris for their continued support; Clarrie Wallis, the curator of the show, and Tim Batchelor for all the hard work they have put in realising such an ambitious project; Sean Rainbird for being such a good ear over many years and for his consistently good advice, and Mathew Hale for his often brilliant suggestions and understanding of the work.

In addition, Tate would like to thank Helen Atkins, Sarah Briggs, Martin Bühler, Lizzie Carey-Thomas, Shaun Clarke, Celia Clear, David Dance, Sarah den Dikken, Sionaigh Durrant, Diana Eccles, Mark Edwards, Steve Felton, Rosie Freemantle, Suzanne Freeman, Ann Gallagher, Christophe Gerard, Ken Graham, Ronald Grant/The Cinema Museum, Charlotte Gutzwiller, Bob Halls, Mark Heathcote, Tim Holton, Gary Hudson, Carolyn Kerr, Pip Laurenson, Ben Luke, Jay Maille, Larry E Martino, Susan May, Rachel Meredith, Kevin Miles, Dale McFarland, Kathleen McLean, Heidi Naef, Nial Parsaud, Dan Pyett, Andrea Rose, Katherine Samsyn, Andy Shiel, Rodney Tidman, John Walker, Glen Williams, Will Wallis, Johanna Wistrom, Loretta Yarlow. We would also like to thank Tisettanta for kindly providing the Minni chairs designed by Antonio Citterio.

OVERLEAF *It Is The Mercy* 1999, carving in handrail
Words from the last page of the logbook of Donald Crowhurst, who disappeared at sea in 1969.

Work commissioned for *New Visions of the Sea*, a contemporary art initiative as part of the Neptune Court development at the National Maritime Museum.